IMAGES
of America

TUFTS
MEDICAL CENTER

IMAGES
of America

TUFTS
MEDICAL CENTER

Robert Bloomberg and Daniel Bird
Foreword by Michael Wagner, MD
President and CEO, Tufts Medical Center

ARCADIA
PUBLISHING

Published by Arcadia Publishing
Charleston, South Carolina

Printed in the United States of America

Library of Congress Control Number: 2015933193

For all general information, please contact Arcadia Publishing:
Telephone 843-853-2070
Fax 843-853-0044
E-mail sales@arcadiapublishing.com
For customer service and orders:
Toll-Free 1-888-313-2665

Visit us on the Internet at www.arcadiapublishing.com

To the doctors, nurses, caregivers, support staff, and benefactors who, over the past 219 years, have made Tufts Medical Center the outstanding hospital it is today

CONTENTS

FOREWORD

In 1796, Boston was not a medical capital—in fact, much of what we take for granted as modern medicine had not been imagined yet. But the need for health care, especially among the city's poorer residents, was clear. A dozen charitable-minded individuals established the Boston Dispensary, the first permanent health care institution in New England and one of the first in the nation, to meet that need. In 1894, just before the Dispensary's centennial, the Floating Hospital for Children was established by the Reverend Rufus Tobey, a Congregational minister who was concerned about the plight of poor children and their mothers. Before the Floating Hospital came ashore permanently, it was hosted aboard two separate ships in Boston Harbor. Doctors and nurses worked tirelessly to provide the best care available to improve the health of children on board, as well as the health of thousands of others through research and invention.

What we now know as Tufts Medical Center grew out of these two institutions, and while medical care has changed dramatically since each was founded, it is remarkable how similar our mission remains. Tufts Medical Center and the Floating Hospital for Children remain on the forefront of not just providing the best care but also advancing care through research and innovation. Our commitment to treating all those in need endures. I personally like to think that if Reverend Tobey and the Boston Dispensary's early benefactors—including patriots Paul Revere and Samuel Adams—could see us now, they would be immensely proud of the lasting impact their institutions have had on Boston and the nation.

ACKNOWLEDGMENTS

Thanks to Patricia Hayward, vice president of human resources at Tufts Medical Center, for her support and commitment to having the hospital sponsor the book. To Deborah Bloomberg and Barbara Bird, our principal supporters and first-line editors. To Elizabeth McGorty at the Tufts Medical Center archives, who helped catalog the images used in the book and who was our research assistant in securing and scanning the book's photographs. And to Myrna Walsh from the South Shore Hospital, who gave us advice and support at the start of the project. Unless otherwise noted, all images appear courtesy of the Tufts Medical Center archives collection.

INTRODUCTION

The history of Tufts Medical Center encompasses the history of medical care in the United States. From its beginnings in the time of George Washington's presidency to the present, the hospital has been an active partner and frequent leader in major advances and innovations in patient treatment, medical education, and research. For well over 200 years, the spirit of the Good Samaritan has guided the work of the hospital, providing health and new hope to its patients.

The years following the Revolutionary War were onerous for the sick poor of Boston. Unless one could afford a private physician, medical care outside the home was nonexistent. Many of the most prominent Boston residents recognized the need for a charitable institution that would serve the needy. Together, they established the Boston Dispensary, the first permanent medical institution in New England, in 1796. Through subscriptions, these sponsors raised sufficient funds to allow 80 patients to be treated in the first year. The apothecary who supplied medicines to the Dispensary's patients was also required to keep an accurate account of the patients, their diseases, and times of admission and discharge. Even then, it appears length of stay played a role in health care.

Although the apothecary shop had several locations on what is now Washington Street, the Dispensary had no fixed location for patient visits until the 1850s. Instead, district physicians called on patients at their homes, or if the patients could walk, they would be seen at the physician's office.

As Boston grew, so too did the Dispensary. The number of physicians and patients dramatically increased, putting a severe strain on the Dispensary's ability to attend to the entire city's sick poor. By the mid-1820s, the Dispensary was treating 1,500 patients a year. A decade later, demand for medical services was so great that the Dispensary divided the city into 10 districts, each requiring the services of a district physician. Among those who recognized the need for a central facility to meet these new demands was Dr. Oliver Wendell Holmes, who served as a Dispensary physician in 1837. He proposed creating a central clinic where patients could be treated more efficiently and doctors could receive training. In 1856, the first permanent Dispensary building opened at Ash and Bennett Streets, marking a new era in the evolution of the hospital.

The second half of the 19th century into the early 20th century was a time of fundamental change in medical knowledge and technology. The discovery of bacteria and germs and the understanding of how diseases were caused and transmitted opened the door to curing disease, not just treating symptoms. The composition of the city was changing as well. Boston's immigrant population exploded; most were poor and could not afford health care. The Dispensary responded by not just expanding in size but also adding new dimensions to its health care program. Several new departments were established, research laboratories began their work, and new techniques for diagnosis were introduced, most notably the x-ray machine. The preparations for modern medical care were well under way.

One major worry for Boston health officials was the dramatic perennial increase in childhood mortality during the summer months. The reason was thought to be the congested and unsanitary

living conditions in the city, and the antidote would be fresh air and sunshine on the ocean. So, in 1894, the Floating Hospital for Children was established and began its summer cruises on Boston Harbor. Along with the benefits of fresh ocean air, its purpose was to provide ship-based medical care free to needy children. The Dispensary, which had always treated both children and adults, worked closely with the Floating Hospital. Their missions were essentially the same, so it was natural for the two institutions to unite in their efforts to help the poor.

One of the signature characteristics of the Dispensary and the Floating Hospital was their emphasis on the "whole" patient. In practice, this meant considering elements beyond their medical needs, such as proper nutrition, mental and physical well-being, and the family's living conditions. Social workers and nutritionists were integral team members, along with physicians and nurses.

As the 20th century unfolded, the Dispensary and the Floating Hospital expanded the traditional definition of hospital care. Innovative techniques such as group psychotherapy for tuberculosis patients, instituting well-child clinics, establishing evening clinics for workers, and even paying doctors a salary instead of a fixed fee became models for other hospitals.

In 1927, a fire destroyed the Floating Hospital ship. Rather than replace the ship, hospital and community leaders decided to shift to a land-based facility that would provide year-round space for treatment and laboratories. Shortly thereafter, Tufts University School of Medicine affiliated with the Dispensary. In 1930, the Boston Dispensary, Floating Hospital for Children, Pratt Diagnostic Clinic, and Tufts Medical School merged into the New England Medical Center. New buildings arose on what was fast becoming the campus of an internationally recognized hospital.

During this transitional period, the hospital was fortunate to benefit from the remarkable efforts and foresight of two physicians, Drs. Joseph Pratt and Samuel Proger. In addition to their many other accomplishments, they rescued several physician refugees from Nazi Germany who went on to become leaders in research and medical care.

Just as the first patients at the Dispensary would not recognize today's Tufts Medical Center, neither would the patients of just a generation or two ago. For example, heart transplants, unknown before the 1960s, are now a specialty of the hospital. Tufts Medical Center has performed more heart transplants than any other hospital in New England. Helicopter MedFlights to the hospital's adult and pediatric trauma centers are commonplace. And who would have foreseen that the hospital receives over $50 million annually in grant funds for medical research and clinical trials?

How did the Medical Center maintain its services, expand, and thrive throughout the vicissitudes of over 200 years of change? One explanation is its benefactors, from individual subscribers and donors to corporations and philanthropists. Three benefactors merit special notice. Benjamin Dearborn in the 1830s, William Bingham II in the 1930s, and the Cam Neely Foundation represent the best in philanthropic largesse. But foremost among the reasons Tufts Medical Center thrives is its physicians, nurses, researchers, and staff, who have consistently provided the highest level of care to its patients. Their unwavering dedication to the highest-quality, family-based health care is summed up in the hospital's mission statement: "We strive to heal, to comfort, to teach, to learn, and to seek the knowledge to promote health and prevent disease. Our patients and their families are at the center of everything we do."

The following pages illustrate the evolution of a small, local Dispensary into a major Medical Center. The narrative is roughly chronological. The book's scope necessarily omits much that is relevant to the story, but such omissions are unintentional and do not diminish their importance.

One

THE BOSTON DISPENSARY

The voices of the first patients of the Boston Dispensary are silent. There is no way of knowing whether they were pleased with the care they received. They left no record of their visits. The reports of the physicians and the apothecary are dry and formal, with just the names, the diseases, and the treatment outcome. But they did keep coming in greater and greater numbers. Word must have spread that the care one received at the Dispensary held more promise than the alternatives: home remedies, the almshouse, or no care at all.

The Dispensary system of district physicians making house calls worked. In fact, the model of providing health care did not materially change for 60 years, and even when there was a permanent location in 1856, a modified district system continued into the 1900s.

Progress moved at a slower pace 200 years ago. Unlike today, when technology is outdated almost before it hits the market, treatment methods, drugs, and medical knowledge in general stayed much the same. But when the course of medicine sped up in the late 19th century and hit full stride in the next several decades, the Dispensary moved right along with the times. The hospital welcomed change; it frequently anticipated it or, in some instances, initiated it.

This chapter illustrates the evolution of the Dispensary from 1796 to its merger with the Floating Hospital for Children and Tufts University Medical School in the 1930s. Today, it is hard to comprehend that medical care once consisted of bloodletting, wine dosages, and laudanum (an alcoholic solution containing morphine, prepared from opium and used as a painkiller) prescriptions. It may be even more difficult to understand that, even in the early 1900s, medical knowledge was so limited that x-rays were used to cure whooping cough in children and no one wore any protection from the radiation beam.

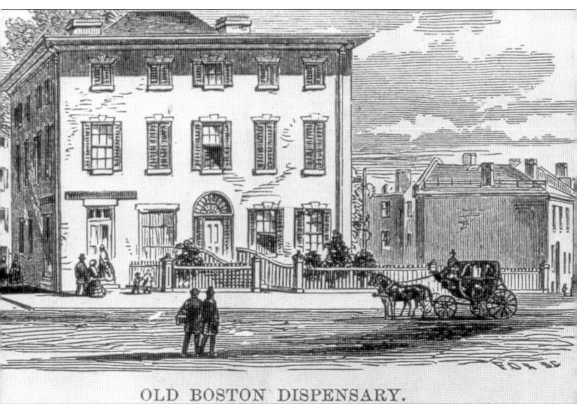

OLD BOSTON DISPENSARY.

In 1796, when the Boston Dispensary was founded, hospitals were scarce and not trusted, often considered a port of last resort. Those who could afford the cost relied on personal physicians; those who could not tried home remedies or simply suffered. In its early years, the Boston Dispensary had no fixed location and few patients. However, the poor residents of Boston quickly recognized its value. By the mid-19th century, the managers of the Dispensary had determined that a central office was needed to meet the burgeoning demand for medical care. This building at the corner of Ash and Bennett Streets was purchased in 1856 as the Dispensary's first permanent location. It was a small, renovated home in what is now known as the city's South End.

The original donors, or subscribers, to the Boston Dispensary included some of the most prominent citizens of the city. Among them was Samuel Adams, eulogized as "the Father of the American Revolution." In addition to playing a vital role in organizing the Boston Tea Party, Adams was a signer of the Declaration of Independence and the governor of Massachusetts from 1794 through 1797.

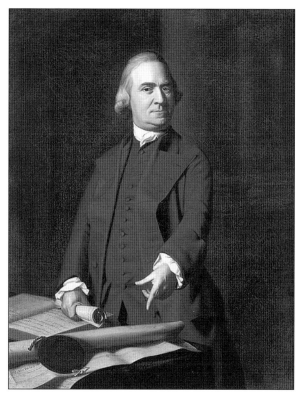

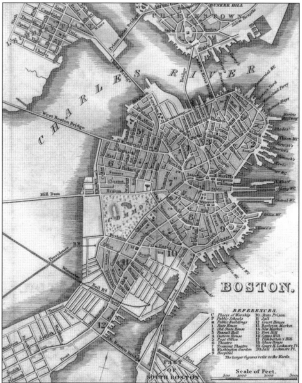

In the years following the American Revolution, Boston was but a small peninsula connected to the mainland by a single street. The portion of this street that housed the Dispensary offices and apothecary was named Cornhill Street. As the city's population grew, so did its land area, much of it through landfill. As the map shows, the Dispensary's current location around Bennett Street was once waterfront property.

13

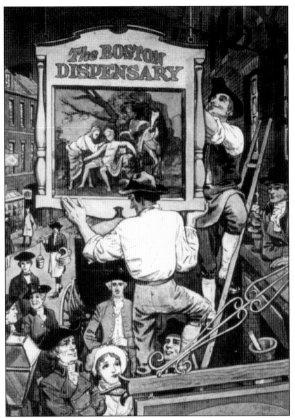

In 1797, the Dispensary adopted the parable of the Good Samaritan as its mission and logo. A Good Samaritan, which originally derives from the Bible, has come to mean someone who helps a stranger. A signboard, hand-carved on wood, hung outside the apothecary shop that served as the first headquarters. As a landmark of 19th-century Boston, the signboard helped attract early benefactors. The image at left is an artist's rendition of the hanging of the sign outside the apothecary shop on Cornhill Street. The original version of the sign now hangs in the boardroom of the Proger Building at the Medical Center. The image below shows the carving of the Good Samaritan, commissioned by Benjamin Dearborn and given in 1839 to the Dispensary, where it hung over the main entrance. It now resides in the administrative offices of the Medical Center.

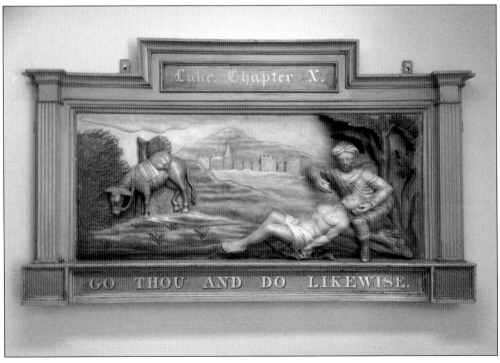

Issued in 1812. See Records page 157.

To visiting **Physician of**
the **District of the Boston Dispensary.**

SIR,

THE Managers of the Dispensary having found it expedient to restrict the issuing of Wine, Medicines, and other articles to the prescriptions and orders of the attending Physicians, feel it incumbent to address you on your being chosen one of this number.

From a desire to afford the unfortunate persons who are now to be under your care, every practicable assistance and indulgence, the Managers make known for your observance the subsequent regulations.

1. It shall be the duty of the attending Physicians, whenever they shall deem it necessary or useful, or the patient shall request it, to avail themselves of the presence and advice of one of the consulting Physicians of the Dispensary, or of any other Physician of the town, he being a fellow of the Massachusetts Medical Society, whom the patient may prefer to see.

2. Our funds are very limited, and as there are always to be found a sufficient number of deserving individuals to exhaust our means, if any person having obtained a recommendation from a Contributor, shall seem in your opinion to be unworthy of the benefits of this Charity, or not entitled to them, you are desired to express this opinion to one of the Managers who shall, if necessary, visit the patient with you, and if he thinks proper, erase his name from the list of patients.

3. An Electrical Machine is put into the hands of the Physician of the Middle District, and two Syringes of different sizes are deposited with each apothecary, for the use of the sick by direction of the Physicians.

4. If in case of accident, any surgical apparatus should be requisite for the sufferer's relief or safety, you are at liberty to supply the article needed, provided the expense in no one case exceeds five dollars ; and present your bill therefor to the Treasurer for payment.

5. The strictest economy is recommended in the distribution of Medicines and Wine ; one quart only of the latter shall be ordered at one time, and that to be Lisbon, or Sherry, or some other not exceeding their value. Port may sometimes be directed, if thought to be peculiarly beneficial ; giving preference to the cheapest that will suit the case. The apothecaries make a separate charge of the following articles which you are at liberty to order, if essentially necessary, namely, Sago, Salop, Oat-meal, Arrow-root, Barley, or Iceland Moss.

6. You are requested to keep an account of the number of patients in your division, and to deliver to the Secretary at the close of each year, a Report comprising the number of your patients, their diseases, and the event or existing state of each case.

If any thing should occur to you as likely to improve this Institution, or to extend its usefulness, you are also requested to communicate your suggestions to the Secretary.

The Boston Dispensary began life in an apothecary shop at 61 Cornhill Street. The first druggists were Drs. Oliver Smith and Thomas Bartlett. Although many medical potions were available, perhaps the largest "prescription" was for wine. In 1806, the district physicians were directed to limit sherry to a maximum of two quarts for any given illness. In the 1812 policies pictured here, the maximum amount of wine was reduced to one quart, although now port was added, provided that preference be given to the cheapest option that would suit the case. Only a few years later, the managers of the Dispensary were questioning whether the $450 per year bill for wine was worth the expense, considering it to be a worthless luxury. They discontinued its use in 1818. It is evident from the policies that, even in these early years, referrals to consulting physicians were encouraged. It is not known what the electrical machine might have been.

Through a system of district physicians, the Dispensary provided free medical care to the needy sick. In 1796, the founding donors envisioned three advantages to this system over a traditional hospital. The patients would be seen at home, at less expense to the public, and without the stigma of being poor. The first physician was Dr. John Fleet, one of the first two graduates of Harvard Medical School. After starting with a single district covering all of Boston, the system had expanded to four districts by 1820, serving over 1,000 patients a year. The number of districts doubled in the next 10 years. Medical students were allowed to substitute for the district physicians and write prescriptions. They were also required to visit the apothecaries once a week to become knowledgeable about the price of medicines. As late as the early 1900s, the district physician was a neighborhood fixture. Both photographs are from 1911.

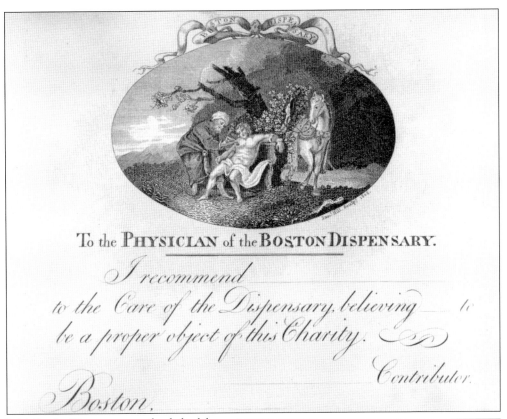

To the PHYSICIAN of the BOSTON DISPENSARY.

I recommend

to the Care of the Dispensary, believing to

be a proper object of this Charity.

Contributor.

Boston,

Initially, the Dispensary was funded solely through donations, or subscriptions. A $5 subscription entitled a donor to recommend two indigent patients to a district physician for treatment. For $50, a benefactor could recommend two patients a year for life. There were over 100 original donors, including England's Prince of Wales and many of Boston's most distinguished citizens. In 1797, subscriptions totaled $310. A typical expense of the time was Dr. Fleet's bill for $119 in 1802. This total included attending 109 patients at $1 per patient and delivering five babies for $10. The Dispensary used a ticket system until 1856. The above image is a blank recommendation ticket. These became necessary because many poor people did not know of any contributors. The image at right shows four representative tickets from the 1850s. Thomas Bartlett, the first apothecary, commissioned the image of the Good Samaritan carving on the tickets to designate his drugstore as the center of the Dispensary's activities.

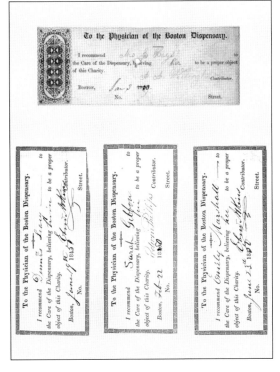

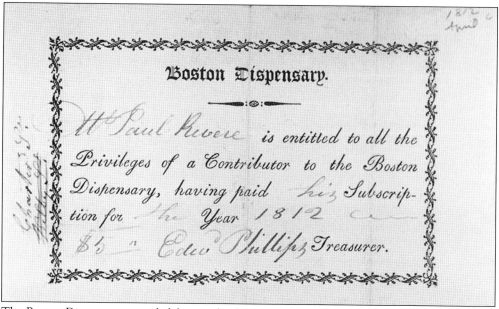

The Boston Dispensary provided free medical care to the poor people of the city. By paying an annual subscription, wealthy donors were entitled to refer patients to a Dispensary physician. This receipt from 1812 belonged to Paul Revere, who famously alerted the Colonial militia to the approach of British forces before the Battles of Lexington and Concord.

During its second year of operation, the Dispensary treated about 80 patients. This list of patients from 1797–1798 suggests the types of illnesses the physicians confronted. Of note, Jonathan Morris died of "dropsy," which is now called edema, or swelling due to excess water accumulating under the skin. Betsey Edes died of "hectic," which described a fever that spiked each day, accompanied by swelling, chills, and facial flushing. It was often associated with tuberculosis or other infectious diseases.

As the Dispensary rapidly expanded, it became clear that there was an urgent need for a system of ongoing care for the poor who were too ill to care for themselves. Thus, in 1814, the Dispensary became the first medical institution in the country to assign nurses to needy patients. The first nurse, who had an office at the Dispensary, accompanied a district physician on his rounds. This photograph of a 20th-century nurse exemplifies their determination and dedication.

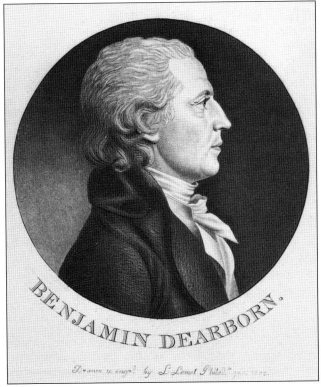

Benjamin Dearborn was a printer, educator, and prolific mechanical inventor. Among his inventions were the gold standard balance, spring scale, ballot box, musical board for the instruction of the blind, and perpendicular lift. He was a major benefactor of the Boston Dispensary, bequeathing $90,000 in 1838—a huge sum at the time. His generosity led to the purchase of the Dispensary's first permanent building, which housed a surgical clinic.

Oliver Wendell Holmes was a poet, professor, lecturer, and author. He was also a distinguished and innovative physician. As a district physician at the Dispensary in 1837 and 1838, he advocated for a central location to treat patients because it would increase efficiency and foster greater collaboration among the physicians. As an important medical reformer, he was dismayed by the "painful and repulsive aspects" of primitive medical treatment of the time, which included practices such as bloodletting and blistering. He composed a series of lectures dedicated to exposing medical fallacies, or "quackeries." In 1843, Holmes published an article titled "The Contagiousness of Puerperal Fever." This work argued that the cause of the disease, which is a deadly infection contracted by women during or shortly after childbirth, stemmed from patient to patient contact via their physician. The controversial essay, which ran counter to the prevailing popular beliefs of the era, is now considered a landmark in the germ theory of disease. In 1846, Holmes coined and then popularized the word "anesthesia." His home at 49 Bennett Street is still being used by the hospital.

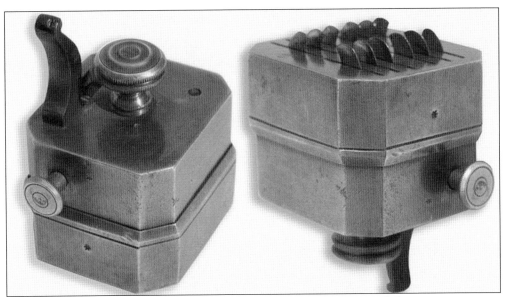

Bloodletting is the withdrawal of blood to cure or prevent illness and disease—a common practice up to the end of the 19th century. One reason for its continued popularity was that, while anatomical knowledge and surgical and diagnostic skills had improved significantly, the keys to curing disease remained elusive. The underlying belief favored any treatment over nothing. The usual method was venesection, in which blood was drawn from a large external vein. In scarification, the superficial vessels were attacked. The above image (used with the permission of Gilai Collectibles, Israel) shows a brass scarificator with 12 steel blades. Pulling the trigger lever at the bottom stretches a spring and cocks the blades. The knob on the side promptly releases them, making cuts in the skin to allow blood drain. The depth of the cuts is adjusted using the knurled screw. The use of leeches was especially popular at the time and is currently making a reappearance because of their ability to restore blood flow to areas of damaged veins after reattaching an appendage or grafting tissue.

BOSTON DISPENSARY.

At a meeting of the Managers of the Boston Dispensary, on the 6th of November, 1833, it was *Voted*, That the Visiting Physicians of the Dispensary, be requested to use in their annual reports, a uniform Nomenclature of diseases ; and to adopt the Nomenclature of the Boston Medical Association, as far as it extends ; and to make such additions to it as may be thought proper by themselves and the Consulting Physicians.

Voted, That the birth or country of the patients be designated according to the following table:—
 American.
 British, (including English, Scotch and persons from the British Provinces.)
 Irish.
 Hibernico American.
 French, Swedes, etc.
 Bostonian.
The last title includes only those persons who are born in Boston of American parents.

Voted, That the Visiting Physicians be requested to employ the following scales, with the characters prefixed, in their annual reports, and to mark every patient with one or more of the prefixes.
 A. Temperate.
 B. Moderate Drinker.
 C. Drunkard.
 D. Child of intemperate parents.

MEANS OF LIFE.
 a. Has ample means, and does not need the aid of the Dispensary.
 b. Has means to provide common comforts.
 c. Has not means to provide common comforts.

MANNER OF LIFE.
 1. Comfortable.
 2. Decent.
 3. Wretched.

Voted, That the Visiting Physicians be requested to notice other circumstances of the patients in their annual reports ; as industry or idleness ; attendance or non-attendance at public worship ; how far supported by charity ; the illegitimacy of children ; and to designate colored patients.

Voted, That the following notice be annexed to each Dispensary ticket and be in every case issued with it. "The patients of the Dispensary are hereby informed, that the Physicians do not receive any " pay for their services ; and that these services will cease to be given in case of neglect, or ill conduct on " the part of the patient."

Voted, That if a patient is unworthy to receive the charity of the Dispensary, and the Physician withholds his attendance, it shall be the duty of the Physician to communicate the fact, with the reasons therefor, to the Chairman of the Board of Managers.

Voted, That copies of the above votes be printed, and one or more be furnished to each Dispensary Physician.

 A copy of the record,
 Attest,
 G. H. SNELLING, Sec'y.

The Dispensary provided free medical care to those poor whom a physician deemed to be a "proper object of this charity," according to William Lawrence's *A History of the Boston Dispensary*. In a circular distributed to the physicians in 1830, the Dispensary managers made it clear that "habitually intemperate and syphilitic patients" would not qualify and that district physicians should not attend them. In 1833, the managers required that reports categorize their patients' social and moral qualities, as seen here. Patients were graded on the amount of alcohol they consumed and their manner of life. Being poor was not an issue, but being idle, not attending church, or having illegitimate children might be cause for disqualification. Times change, and a generation later, in 1873, the Dispensary established the first permanent clinic in the country for the treatment of syphilis.

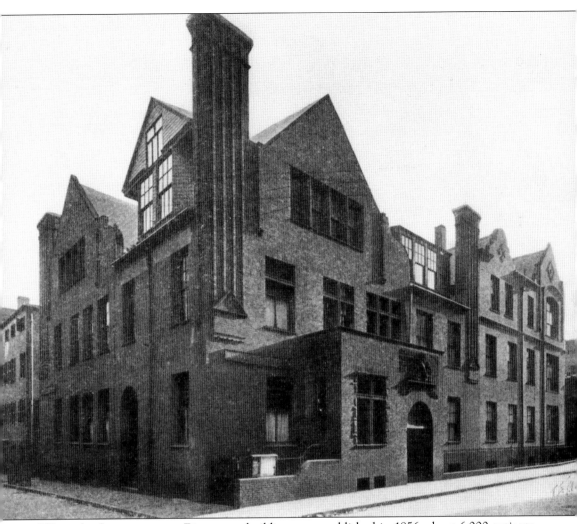

When the first permanent Dispensary building was established in 1856, about 6,000 patients visited this new central office. By 1868, that number had risen to 16,000, then to 26,000 in 1883. To accommodate this expansion, a larger, more modern building was necessary. Thus, in 1883, the old town house was demolished, and the second Dispensary building was erected at 2 Ash Street. Described at the time in *The Grand Dame of Medicine: The Boston Dispensary* as "plain, commodious and substantial," it was twice the size of its predecessor. In this photograph from 1908, the imposing size of the structure is evident. Visible over the entrance archway is the sign of the Good Samaritan. The building has been substantially altered in the intervening century, as has Ash Street, which no longer exists at this location. The Dispensary building now faces the atrium of the hospital. Today, the building houses offices, laboratories, and other modern usages, such as the hospital credit union.

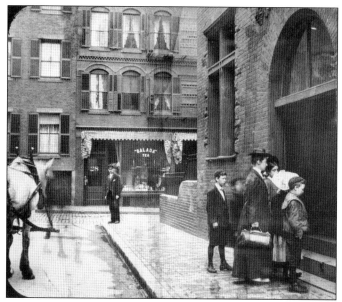

In its first century, the Dispensary attended 1,378,845 patients. Over 90 percent of these were seen after 1856, reflecting the social and economic changes resulting from the huge influx of mostly poor immigrants to Boston. In this photograph from 1910, a mother and her children approach the entrance to the Dispensary to receive the care otherwise unavailable to them. Alternatively, the system of district physicians enabled entire families to be treated at home should they be unable or unwilling to travel.

Around the turn of the 20th century, over 5,000 people died of tuberculosis in Massachusetts each year. In response to the prevalence of the disease, especially in the crowded and poorer areas of Boston, the Dispensary opened the first lung clinic in the United States in 1899. Leading the clinic was Dr. Edward Otis, recognized as one of the world's authorities on "the plague of the ghetto." Physicians treating tuberculosis recommended that patients sleep on their rooftops to take advantage of the fresh air.

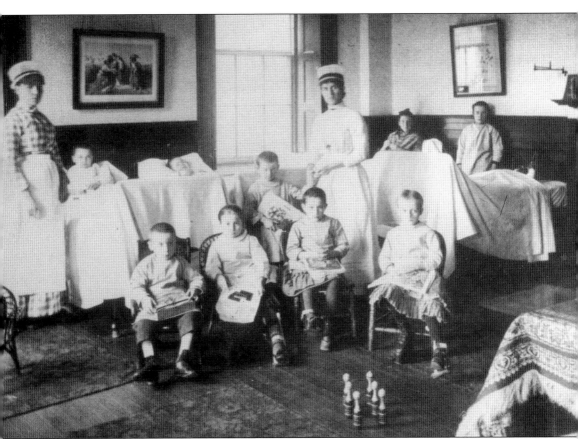

Pediatrics as a medical specialty did not exist in 1797 when the Dispensary opened. Children were seen and treated alongside adults. The first children's hospital in the United States did not open until 1855 in Philadelphia. The specialty developed slowly through the 19th century, probably because there was very little a physician could do to treat or cure childhood diseases. In 1883, the Tyler Street Day Nursery opened, providing child care for working mothers and children needing medical care, as well as training for nursemaids. In 1908, the nursery allowed the Dispensary to use its building as an inpatient facility for children. Three years later, the Dispensary took over the nursery, using the proceeds of the sale of the Tyler Street building to add a floor to the Ash Street Dispensary. The facility became known as the Hospital for Children. This is a c. 1900 photograph of a room in the nursery.

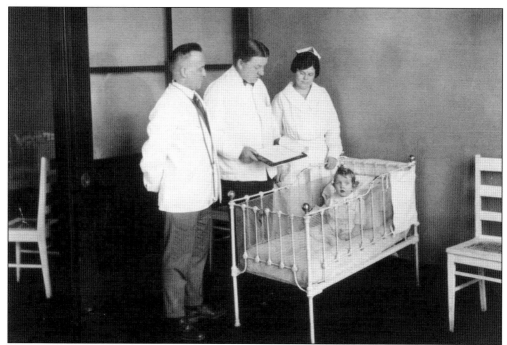

The Children's Department at the Dispensary was officially recognized as a discrete unit in 1904. It had grown to seven rooms and become a center of child vaccinations for smallpox. Over 17,800 children were treated in 1908. The Children's Department complemented the Floating Hospital by providing care in those months when the boat could not cruise the harbor. In 1931, the Dispensary, Floating Hospital, and Tufts Medical School merged to form the New England Medical Center. Pictured above are Dr. Edward Barron (left), the Floating Hospital's chief of staff, and Dr. Elmer Barron (center), chief of the Dispensary's children's clinic since 1917, along with an unidentified nurse. They are discussing a baby brought in to the babies' clinic at the Dispensary around 1930. The below photograph from the same era shows Dr. Elmer Barron (right) and an unnamed doctor consulting with a mother about her baby's health.

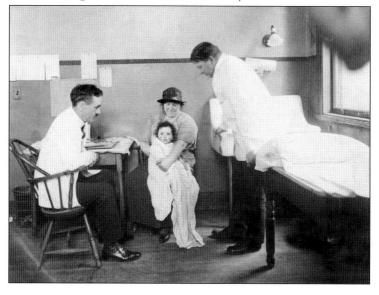

Medical research has been fundamental to the mission of Tufts Medical Center since its inception. As early as 1900, a clinical laboratory was in full operation at the Dispensary, and in 1909, the Floating Hospital established its clinical laboratory. In 1902, Dr. Joseph Pratt developed the first accurate method for counting blood platelets. In the 1930s, Dispensary physicians discovered the link between obesity and heart disease. A separate research laboratory opened in 1935. In the 1940s, Dr. Edwin Astwood demonstrated that hyperthyroidism could be controlled without surgery through the use of drugs. In 1959, the Ziskind Research Building was formally dedicated. This event represented the culmination of a fundraising campaign that included almost $1.8 million bequeathed to the hospital by Jacob Ziskind. When Dr. Sheldon Wolff was appointed chairman of the Medical Department in 1977, he began the systematic recruitment of national leaders in research and patient care to head the hospital's clinical departments. The photograph at right from about 1902 and the one below of the clinical pathology laboratory around 1940 show Dispensary laboratory technicians hard at work.

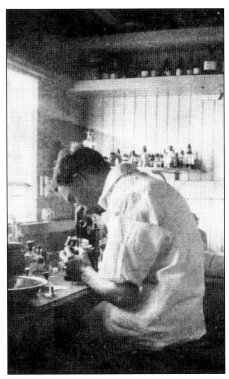

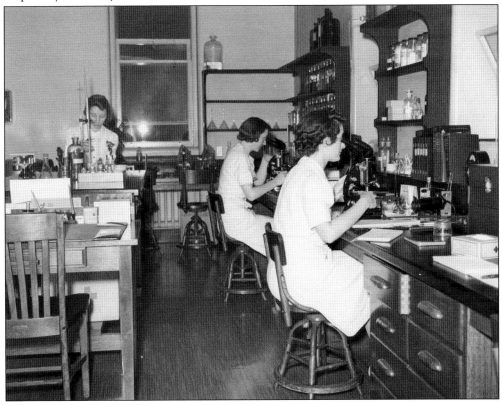

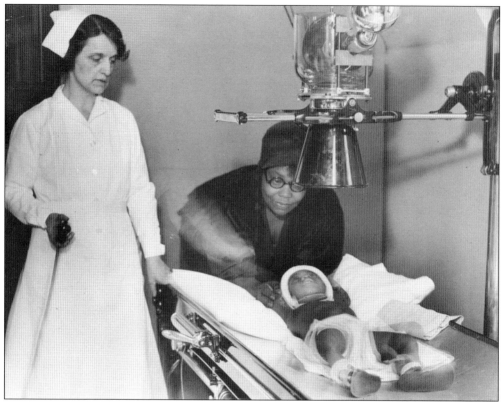

At the turn of the 20th century, the trend in hospital care moved toward diagnosis of disease, not merely the treatment of symptoms. New diagnostic tools were introduced, most notably the x-ray. William Roentgen conducted the first x-ray, of the bones in his wife's hand, in 1895. Within a year, x-rays were being used to find bullets in wounded soldiers. Letting a stream of fast electrons come to a sudden stop at a metal plate produces medical x-rays according to the absorption rates of different tissues. Calcium in bones absorbs x-rays the most, so bones look white on a film recording of the x-ray image, called a radiograph. The X-Ray Department at the Dispensary was founded in 1901. Yet the dangers of x-rays were not fully understood until as much as 40 years later. Above, a baby is undergoing a chest x-ray in the early 1920s. The baby's mother observes as a nurse operates the machine. Below, an adult patient is undergoing deep x-ray therapy around 1937.

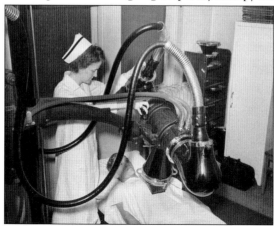

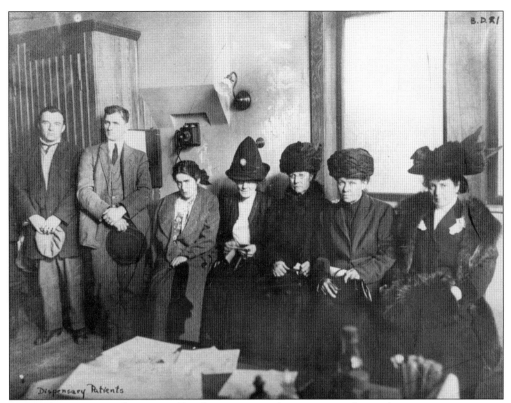

Dispensary Patients

Hospitals were once a last resort. For the most part, physicians were limited to treating symptoms, as curing disease was usually unattainable. But by the turn of the 20th century, a revolution in medical knowledge had permanently altered the landscape. The demand for services far outstripped the available resources. In 1900, there were about 100 dispensaries in the United States; by 1918, the number had climbed to 1,000. From 1888 to 1908, the number of visits to the central office of the Boston Dispensary more than doubled, averaging over 300 a day in 1904. To meet this sea change in health care, the Dispensary added evening clinics, new specialty clinics, and for the first time, lay professional administrators. Above, five women and two men wait to be seen by clinic staff around 1910. Below, six years later, the waiting time to be seen had evidently increased dramatically.

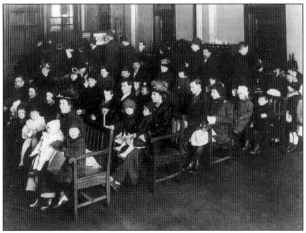

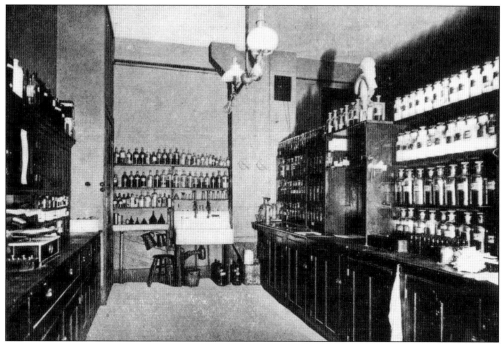

The Dispensary started in an apothecary, with wine, port, and sherry leading the list of prescribed "drugs." Not much changed in the 19th century. By the turn of the 20th century, medical care had evolved from the treatment of symptoms to an emphasis on aids to diagnosis and prevention of disease. This shift in approach, along with technological advances in medicine, led to significant changes in what was prescribed. In 1908, Dispensary physicians saw about 130,000 patients and wrote over 82,000 prescriptions. In the following year, the first Dispensary formulary, or official list that gave the details of prescribed medicines, was established. Above, a 1904 photograph of the Dispensary pharmacy vividly illustrates the explosion in new drugs, many of which had to be prepared by the pharmacist. By the time the photograph below was taken, ready-made commercial drugs had become the rule rather than the exception.

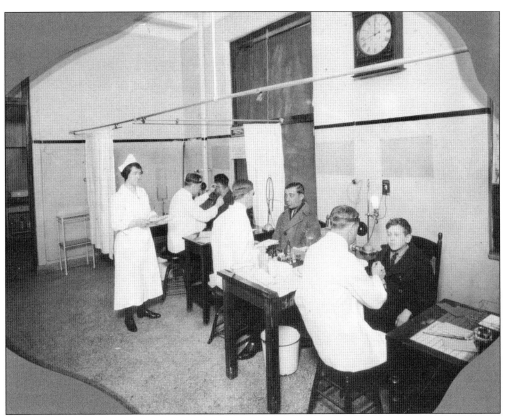

The Department for Diseases of the Ear opened at the Dispensary in 1870. As one of the first specialty clinics, it was combined with the Throat and Nose Department in 1918 to form the Ear, Nose, and Throat Department. Its descendant, today's Otolaryngology Department (Head + Neck Surgery), carries on a century-old tradition of excellence in diagnosis and treatment. As the above photograph from 1924 suggests, a doctor's visit was once a formal affair. Three patients are being examined at the Dispensary's Ear, Nose, and Throat Clinic. All the doctors are wearing head mirrors, a simple diagnostic device. The mirror reflected light from a lamp, affording the physician an excellent view. Because of their common use, head mirrors became a stereotypical part of a physician's uniform in comic routines. In the 1934 photograph at right, a child grimaces, perhaps in anticipation of pain, as the doctor conducts his examination.

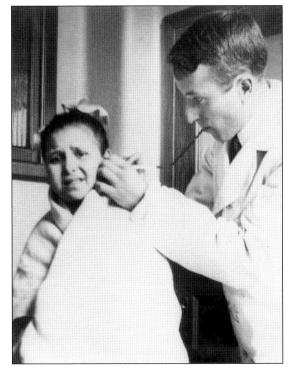

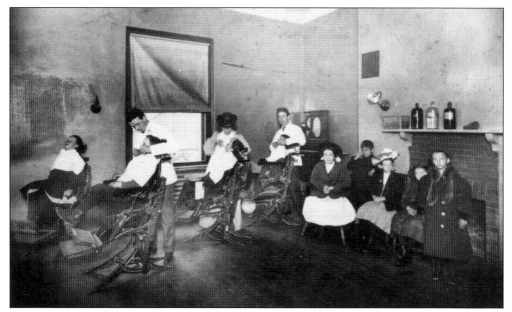

For much of the 19th century, dentistry was considered a regular part of a physician's overall responsibility. Going to a dentist was therefore a new experience when the first dental clinic became available to the sick poor at the Dispensary in 1873. A typical dentist worked part-time; one dentist charged $25 for the first quarter of that year. At the time of these photographs, above in 1914 and below in 1938, the standards of hygiene were not as stringent as they are today, as none of the dentists are wearing gloves. Waiting patients are seated next to the treatment area as well. Today, the Medical Center's dental practice, in conjunction with the colocated Tufts University School of Dental Medicine, provides access to specialties such as geriatric dentistry, prosthodontics, endodontics, periodontics, esthetic dentistry, oral and maxillofacial surgery, and oral hygiene.

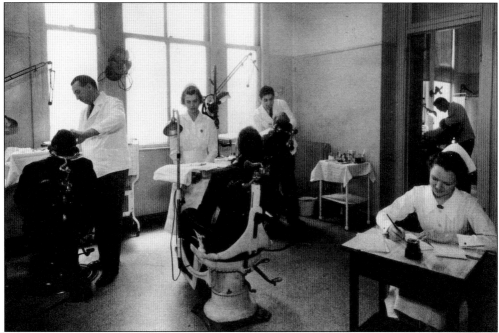

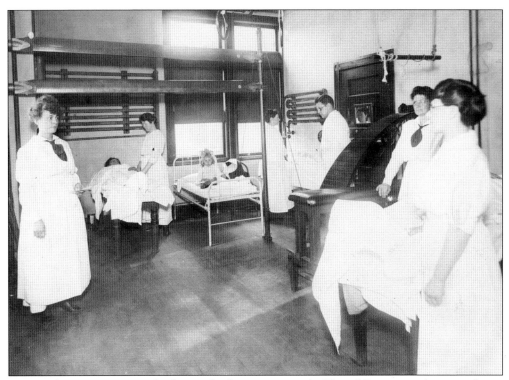

In 1893, the Dispensary was the first medical institution in the United States to make scientific use of Swedish, or classical, massage, marking the beginning of physical medicine. It was introduced into the Dispensary by Baron Nils Posse, who is considered the most influential person in introducing Swedish gymnastics to the United States. The undated photograph above shows the massage clinic, a precursor to later rehabilitation departments at the Dispensary. The below photograph, taken in 1916, gives an example of nascent occupational therapy. A therapist in the Dispensary's Massage Department is treating a worker's arm to help bring it back to full use. In 1946, the Department of Physical Therapy was created, followed by the Department of Physical Medicine five years later. By 2007, massage therapy had become the most prevalent type of alternative medicine in US hospitals.

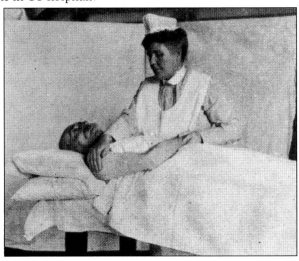

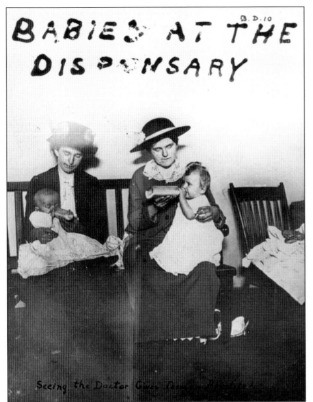

BABIES AT THE DISPENSARY

B.D.10

Seeing the Doctor Gives Baby an Appetite

Finding adequate funding for the Dispensary was always a challenge. Subscriptions did not cover the increased demand for the growing number of specialties and services offered by the hospital. Between 1900 and 1910, two additions were appended to the main building, and in 1912, a fourth story was added. Fees for dental, prescription, and surgical services had been routine for some time prior to 1908 for those who could afford to pay. In that year, the Dispensary instituted a general admission fee of 10¢ per visit. Then, to accommodate working people, the Dispensary opened an evening clinic in 1916. The $1 fee approximated the cost. The c. 1908 photograph below depicts the main hall of the Dispensary. The c. 1920 photograph at left shows mothers feeding their babies, perhaps in the recently opened children's preventive clinic of the Dispensary.

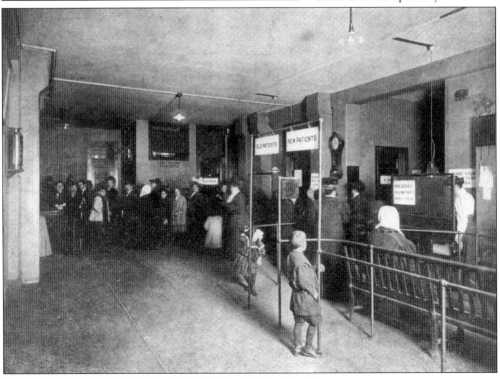

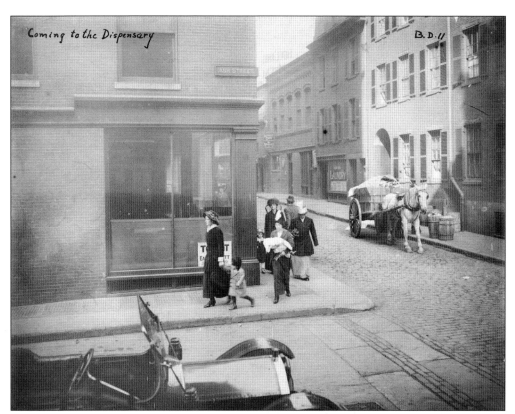

The Dispensary treated both adults and children from its inception. In the view above from about 1913, a family is seen walking toward the Dispensary building. The appointment system was not adopted in Boston hospitals until the late 1920s. Patients simply came and waited their turn. The transition from old-fashioned medical treatment to new advances in knowledge and technology is symbolized by the family walking away from the horse and wagon on cobblestoned Bennett Street and toward an automobile parked on Ash Street. The empty store with the "To Let" sign in the window is now the location of the hospital's main entrance and atrium. At right, mothers and their children have their picture taken in front of the Dispensary around 1900. The man with the derby hat in the doorway at left is likely to have been a Dispensary physician. The woman behind him is probably a nurse.

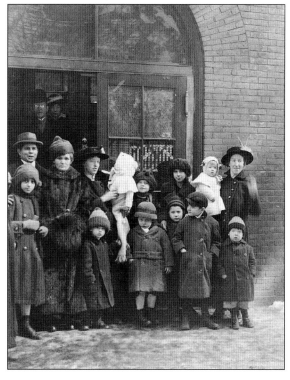

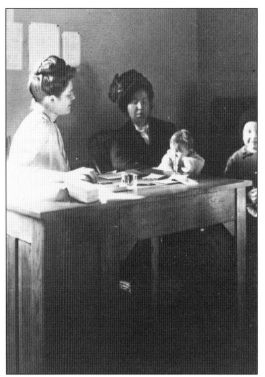

In a 1908 report, a district physician noted, "It is not so much the medical cases that perplex the doctor, but more the hygienic and social problems which confront him." Not coincidentally, medical social work began at the Dispensary the next year with the appointment of Elizabeth Richards Day as the first caseworker, only the second social work department in the country. Nurses provided daily follow-up reports on discharged patients. Michael Davis Jr., appointed as the first lay administrator of the Dispensary in 1910, led the way in applying social techniques to the treatment of medical patients, presaging the HMO model of medical care. In its first full year of operation, 1,200 patients, the majority from either the tuberculosis or children's clinics, were referred to social workers through the Dispensary physicians. In the 1910 photograph at left, a mother is telling the social worker about her baby. In the one below, taken about 20 years later, the social worker, now an admitting officer, is interviewing a prospective patient.

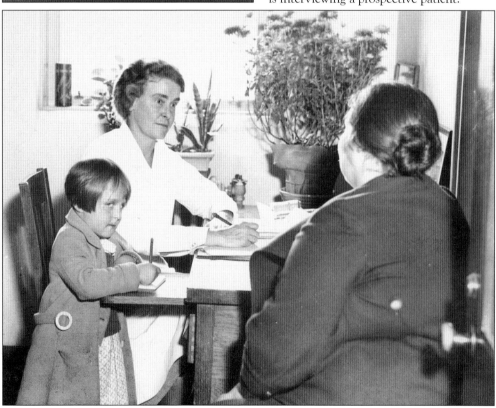

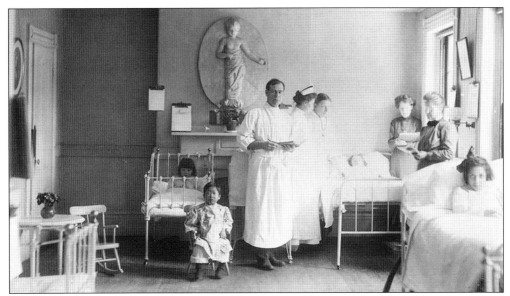

In 1908, the Tyler Street Day Nursery allowed the Dispensary to use its building as a children's inpatient facility that became known as the Hospital for Children. This 1911 photograph shows a team of a physician, nurses, a social worker, and a stenographer gathered around the bed of a small patient. This team approach to medical care is now a standard methodology in modern hospitals.

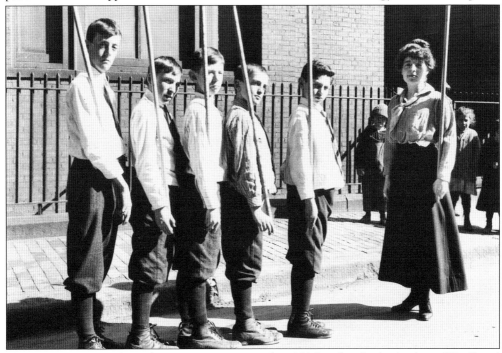

The Dispensary's Orthopedic Department opened in 1886 under the leadership of Dr. Royal Whitman, a nationally recognized leader in hip and leg surgery. His willingness to innovate and experiment set the tone for the new area of specialty. Although these boys look well, each had something wrong with his back. The Dispensary building on Ash Street is seen in the background as the boys perform posture exercises around 1910.

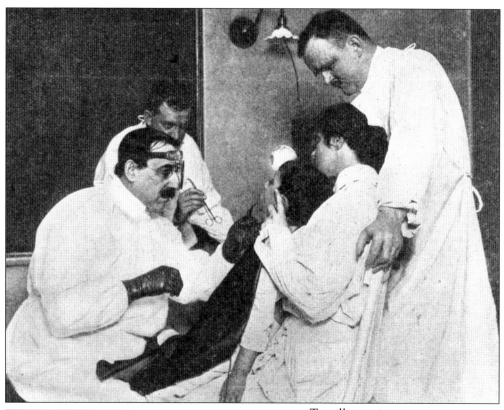

Tonsillectomies are an ancient surgical procedure, first mentioned in Hindu literature 3,000 years ago. Originally performed by general surgeons, tonsillectomies like the one seen here in progress at the Dispensary had become the specialty of ear, nose, and throat surgeons by the time of this 1911 photograph. Note that only one doctor is wearing protective gloves, and none have face masks.

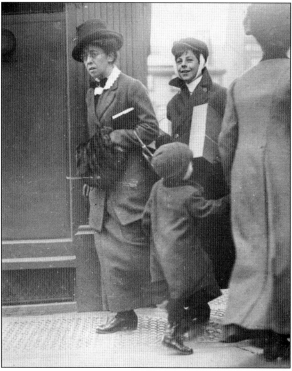

When the Dispensary was founded in 1797, the causes of disease were unknown. Treatment consisted of alleviating symptoms and making the patient comfortable. By 1900, the trend was moving toward diagnosis of disease. This 1912 photograph was taken outside the Dispensary. The mother seems worried that her son has an earache, but the boy shows no concern at all.

The establishment of a central Dispensary office in 1856 led to the development of over a dozen specialty departments by the early 1900s. The Dispensary became the premier facility for underprivileged specialty care in Boston. In this 1916 photograph, a woman has come to the Orthopedic Department to have her stiffened hands limbered up by being heated, or "baked."

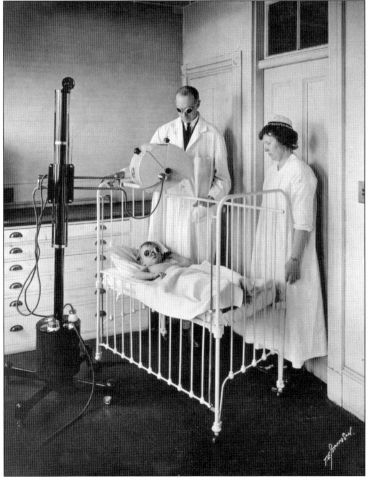

Rickets was a crippling and often fatal disease that affected children. Although its cause is now attributed to vitamin D deficiency, the origin and treatment of this disease remained unknown as late as World War I. In the 1920s, clinical research proved that sunlight cured infantile rickets and that ultraviolet rays, as seen here, were equally effective. Milk was also treated with ultraviolet rays to make it safer to drink.

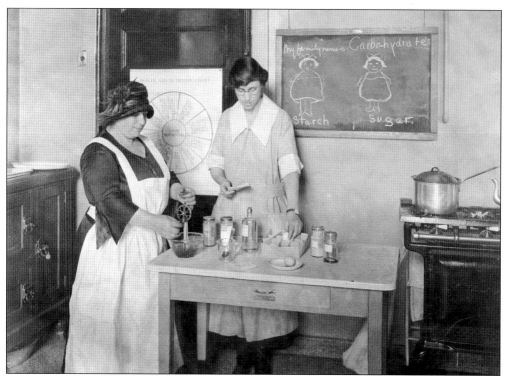

Established in 1918, the Dispensary's Food Clinic, founded by Frances Stern, was the first of its kind in the world. It became the model for all subsequent clinics. Initially, the clinic assisted with medical treatment, but its function expanded to teaching the relationship between food and the body for both adults and children. The clinic provided instruction and counseling for weight loss and became a center for the training of health care and social service workers. In 1920, the Dispensary established a nutrition education department, and in 1926, the Floating Hospital opened a nutritional defects clinic for children. The connection of starches, carbohydrates, and sugar to childhood obesity are graphically depicted on the blackboard above, and an adult nutrition class is pictured below. To honor its founder, the clinic was renamed the Frances Stern Food Clinic 25 years later. Today, Tufts University operates the Jean Mayer Human Nutrition Research Center on Aging, located on the Medical Center's campus. Its mission is to continue Stern's work in exploring the relationship between nutrition, physical activity, and healthy and active aging.

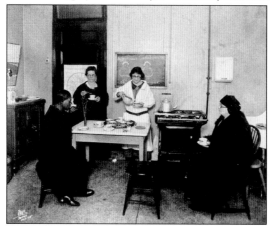

Today, preventive medicine is a medical specialty that aims to protect, promote, and maintain health and well-being and to prevent disease, disability, and death. In the early 20th century, however, it was a novel concept. Around 1911, a well-child clinic, the first of its kind in the country, was inaugurated. In 1918, the Dispensary opened its first health clinic for both children and adults. For $5, those with medical concerns but who were not acutely ill could have a checkup or exam, with the findings sent to the family doctor. It offered a complete medical exam, chest x-ray, and laboratory work, with consultation in any department necessary. In the 1940s, it was renamed the Diagnostic Clinic. At right, a direct poster campaign encouraged the public to take preventive steps to address potential health problems. Below, mothers and babies are seated in the clinic waiting room in 1916.

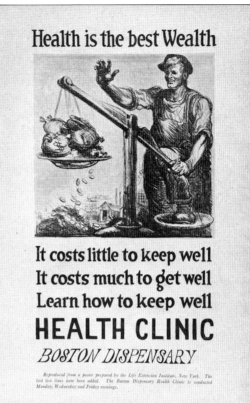

Health is the best Wealth

It costs little to keep well
It costs much to get well
Learn how to keep well
HEALTH CLINIC
BOSTON DISPENSARY

Reproduced from a poster prepared by the Life Extension Institute, New York. The last two lines have been added. The Boston Dispensary Health Clinic is conducted Monday, Wednesday and Friday evenings.

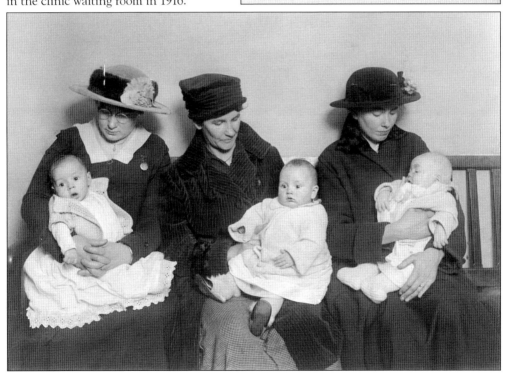

Oliver Wendell Holmes's seminal 1843 paper on the causes of puerperal fever was either ridiculed or ignored for years. According to his research, the doctor himself would often carry the sometimes fatal disease from one woman to another due to a lack of sanitization between patients. Fortunately, maternity care evolved from those dismal days. As early as 1881, the Dispensary had the Department for Diseases of Women, which became the Gynecological Department in 1908. The Obstetrics Department opened in 1885. With the opening of the maternity service in 1992, the New England Medical Center became the first full-service teaching hospital in Boston. The smiling mother in this undated photograph proudly holds her quadruplets, who seem largely unaffected by all the attention.

The first state-aided cancer research clinic in the Boston area opened at the Dispensary in 1916. It combined with the Department of Skin Diseases and Syphilis. In 1926, eight beds of the Floating Hospital were set up for the short-time study of cancer and syphilitic patients and for "the observance of obscure medical conditions," according to *150 Years: A Good Samaritan*. In this c. 1942 photograph, a laboratory technician checks sutures in an anesthetized mouse in a study on endocrine factors in cancer.

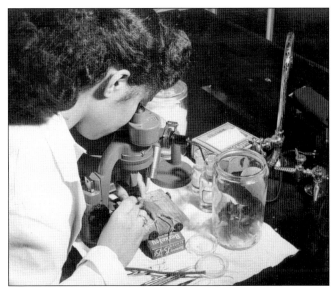

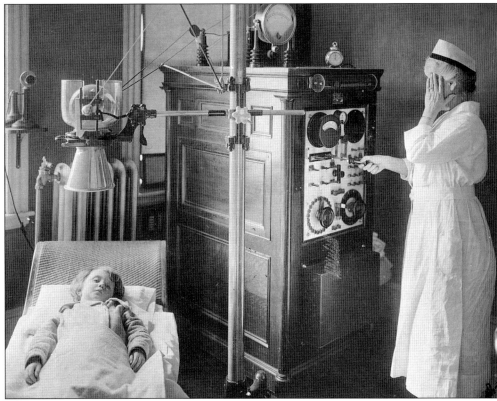

Whooping cough was a highly contagious respiratory tract disease that commonly affected children. Prior to the discovery of the bacteria that causes the disease and the development of a vaccine, treatments were usually unsuccessful. In 1923, Dr. Henry Bowditch, chief of pediatrics at the Floating Hospital, investigated the efficacy of x-rays to treat the disease, which proved to be remarkably successful. Although other contemporary studies confirmed Dr. Bowditch's results, none could explain why the x-rays worked.

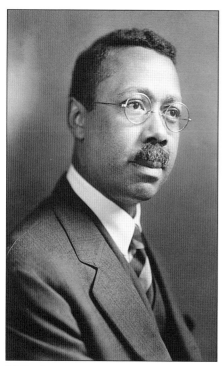

Dr. William A. Hinton, the son of former slaves, has the distinction of being the first African American graduate of Harvard Medical School and the first black professor in the history of Harvard University. Dr. Hinton was also chief of the Clinical Laboratory Department at the Boston Dispensary for decades. Among his accomplishments there was developing the Medical Laboratory Techniques course in 1931 to train laboratory technicians. His training program included women, though the profession was not generally open to them at the time. Dr. Hinton became a world-renowned expert in the diagnosis and treatment of syphilis. A pioneer in the field of public health, he developed a diagnostic test for syphilis, known as the Hinton test, in 1927, and the US Public Health Service later endorsed it. The test is still in use today. The William A. Hinton Research Training Award, given in his memory by the American Society of Microbiologists, honors outstanding contributions toward fostering the research training of underrepresented minorities in microbiology. In the 1928 photograph of the Dispensary Committee on Research, he is seen at right in the second row.

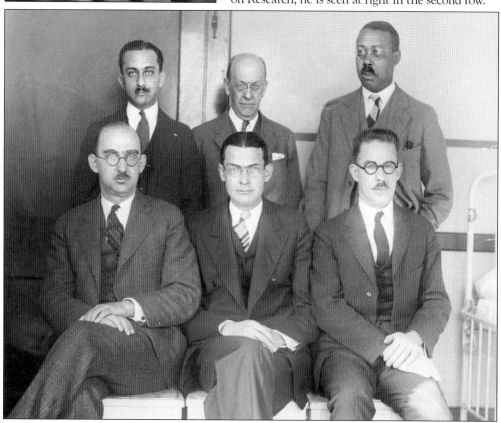

From its inception, the Boston Dispensary has been a superior training school for some of the most distinguished physicians in the country. Throughout the 19th century, becoming a district physician was regarded as a crucial residency experience for any medical student who wanted to build a practice in Boston. Since 1929, the Medical Center has been the principal teaching hospital of Tufts University School of Medicine. Founded in 1892, the medical school is known for its substantive and innovative medical curriculum. Today, more than 300 Tufts University medical students train at the Medical Center each year, and much of the hospital's medical staff has teaching responsibilities at the medical school. Doctors were trained at the hospital and at the patient's home to ensure a hands-on education. At right, medical students observe the treatment of an elderly patient at the Dispensary in the late 1920s. Below, a later generation continues the mission of the teaching hospital.

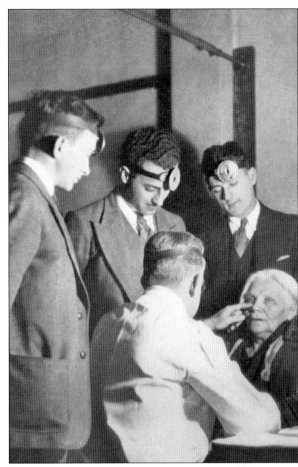

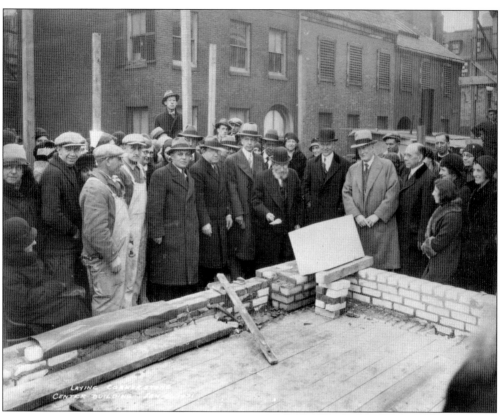

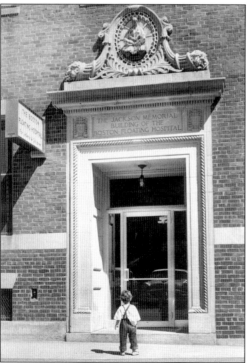

After the Floating Hospital ship was destroyed by fire in 1927, the board of trustees concluded that medical care had progressed beyond the benefits of fresh air. They decided to construct an onshore facility that would provide sufficient space for all the hospital's needs. Thus, the Jackson Memorial Building was constructed next to the Dispensary in 1931. It was named in honor of brothers Henry and Paul Jackson, whose trust funded much the project. The trust's motto summed up their mission, "To provide for the children of Boston," which is precisely what the Floating Hospital does. The children's inpatient ward at the Dispensary was transferred to the new building, and thereafter, all pediatric inpatient activities became the province of the Floating Hospital. Above, Dr. Merritt Eddy of Vermont is holding the trowel at the cornerstone ceremony in December 1930. At age 98, he was the oldest living doctor in New England at the time. He practiced medicine for over 65 years. At left is the entrance to the Jackson Memorial Building.

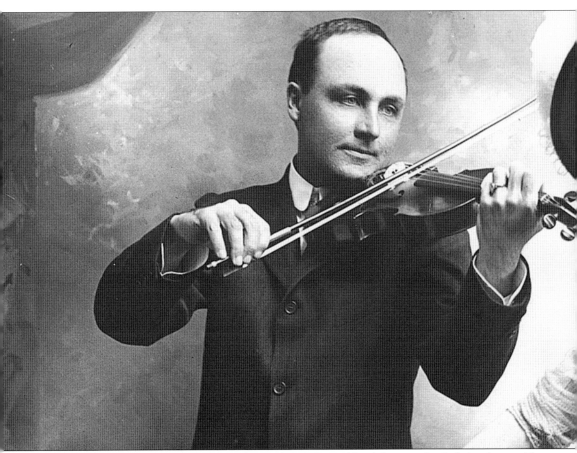

William Bingham II, pictured playing his violin, dedicated his life to medical philanthropy. He donated more than $7 million to help finance the growth of Tufts–New England Medical Center, including the Pratt Diagnostic Clinic, which grew into the Pratt Diagnostic Hospital. Bingham insisted that the new hospital be named after Joseph Pratt, the doctor who had successfully operated on him. Throughout the 1930s, he helped fund the Center Building and staff salaries, in addition to underwriting clinic deficits. He purchased land for the relocation of two Tufts University health sciences schools and contributed to the construction of both the Proger and Farnsworth Buildings. Bingham's influence on health care extended well beyond New England. The Bingham Associates Program, which emphasized regional medical care, took on a consultative role for hospitals to help improve organizational, technical, and medical aspects of their operations. Based on this concept, in 1946, Congress passed the Hill-Burton Hospital Construction Act, which authorized $75 million for matching grants to help build hundreds of hospitals throughout the United States.

In its long history, Tufts Medical Center has had its share of famous patients. Among them were Arthur Fiedler, Pablo Casals, Serge Koussevitsky (former conductor of the Boston Symphony Orchestra), and Chiang Kai-Shek (president of the Republic of China), but as this photograph symbolizes, in its more than 200 years of service, the Medical Center has never veered from its focus of dedication to healing the poor and disadvantaged.

Two

THE FLOATING HOSPITAL FOR CHILDREN

As with many historic achievements, the Boston Floating Hospital for Children was conceived by a person with a fresh vision, a desire to make a difference, and a unique remedy. That person was the Reverend Rufus B. Tobey.

Tobey's Boston in the late 1800s was growing rapidly, with a surging population of poor, uneducated immigrants. Health care for most was unavailable, and pediatrics as we now know it did not exist at that time. Nationwide, only a handful of doctors exclusively treated babies and young children. It is not that there was not a need, because by the late 1880s, one in 10 children less than five years old would die before the age of five of what were broadly called children's diseases.

One summer's evening in 1893, while crossing the Dover Street Bridge on their way home, Tobey and his assistant Lewis Freeman noticed that there were many mothers and fathers walking with their babies and young children along the bridge. The parents were there to get away from the stifling air of their tenements and to give their children some fresh ocean air to breathe. The children for the most part were not just hot, they were sick, most of them very sick. Although the fresh air would not cure them, it did at least help them breathe and made them more comfortable. It was about all a parent could do to help.

Greatly touched by what he saw, Tobey was moved to action. He brought his vision back to the many social organizations with which he was associated, and together, they sought a solution. One answer occurred to them. They had heard of a hospital ship in New York and set about duplicating one for the sick children of Boston. Being on a ship would certainly give the children plenty of fresh air, but more importantly, it would give them an opportunity to be seen by doctors and nurses. Soon, sufficient money was raised, and the task of finding a suitable and affordable ship was at hand. What they found was a barge named *Clifford*. The sick children of Boston finally had a fighting chance.

The origins of the Floating Hospital are now legend, but the story did not end with that first ship. The Floating Hospital for Children has prospered, and today, it is a major pediatric teaching hospital and venerable Boston institution.

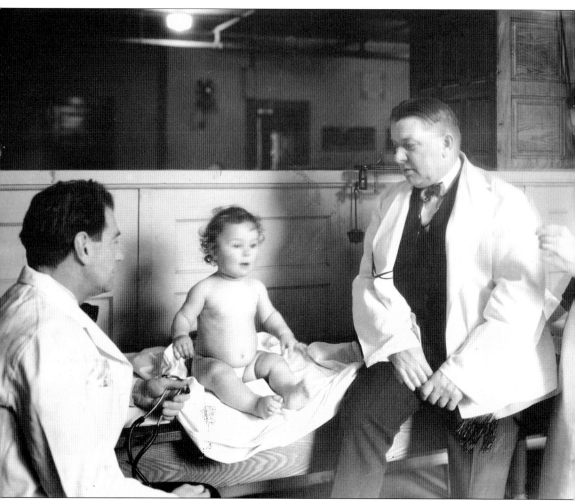

In the 19th century, there was little understanding of how and why children got sick, and even less awareness of how to treat their diseases, thus few doctors took an interest in following that line of medical practice. By extension, babies and small children were most often seen by the mother's obstetrician. For lack of any special knowledge about their illnesses, children were most often treated as smaller versions of adults. Not only were their unique medical needs largely ignored, but the community at large also paid little attention to alleviating many of the causes of the ailments. Factors such as substandard living conditions, poor hygiene, contaminated food, and unhealthy air were major contributors to the rampant illnesses present at the time. Diseases that were often fatal included diphtheria, measles, and whooping cough, but the most common summer affliction was called cholera infantum, an acute intestinal infection. The medical professionals at that time had no cure for this disease and could only recommend good food and fresh air as a way of relieving the babies' symptoms. By the time of this 1930s photograph, the causes of many of these diseases had been identified, and cures were on the way.

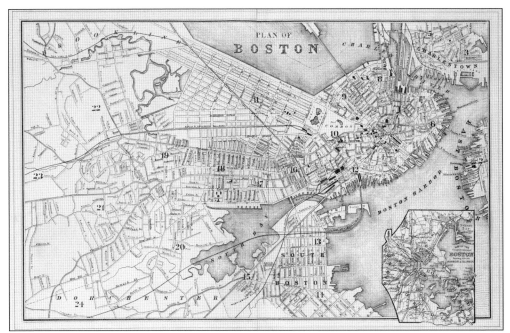

At the time the Floating Hospital came into being, Boston was expanding at an astounding rate, both in land area and population. From 1850 to 1890, its population doubled. These new Bostonians came with little money, education, or skills. They also came with old-world home remedies for childhood diseases that were many times at odds with the new health care practices emerging at the turn of the century. By comparing this map from 1856 with the one on page 13, it is evident how much land had been filled in to accommodate the needs of the newly arrived residents.

The Dover Street Bridge connected the South End with South Boston and offered a favorite promenade for citizens wishing to view the city. It was on this bridge that Reverend Tobey saw parents walking back and forth holding their babies in an effort to give them relief with the fresh ocean air.

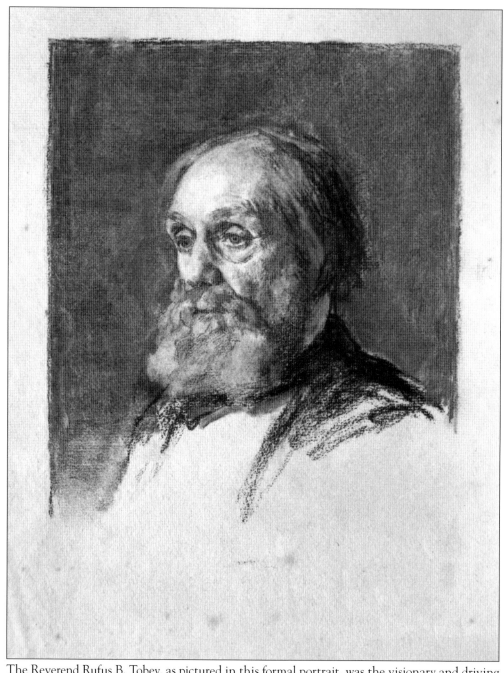

The Reverend Rufus B. Tobey, as pictured in this formal portrait, was the visionary and driving force that brought the Floating Hospital into being. Reverend Tobey was an active leader in Boston's network of social service organizations and pastor of the Berkeley Street Temple, which served the city's poorest citizens. He was also a member of the Ten Times One Society, founded by Edward Everett Hale, who wrote the story "Ten Times One Is Ten," which influenced social service organizations around the country. The society played a major role in raising money for the Floating Hospital. Reverend Tobey not only founded the Floating Hospital but also continued to serve as its director for over 20 years.

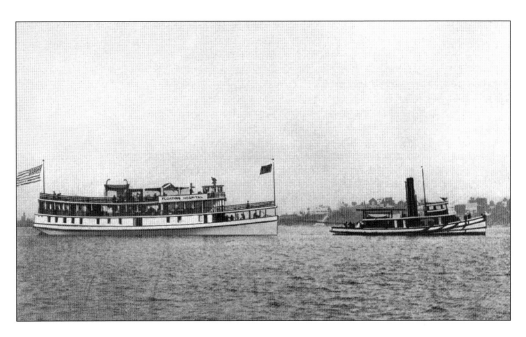

Pictured is the *Clifford*, captained by E.W. Sears and pulled through Boston Harbor by the tug *Leader*. Built in Bangor, Maine, in 1876, the *Clifford* was used as a sightseeing and entertainment ship for evening revelers. Before 1897, when it was finally purchased for sole use as a hospital ship, the *Clifford* was stripped of its evening accommodations each morning to make room for the necessary hospital beds and medical supplies. On July 23, 1894, its maiden voyage as a Floating Hospital was met with huge fanfare and publicity. That first day was a great success, with more than 30 babies and small children on board. For the first time, sick children got more than just fresh air. They got the medical attention they so badly needed. The lowly barge *Clifford* proudly served as the Floating Hospital for Children from 1894 to 1906, providing care for over 11,000 sick children in that time.

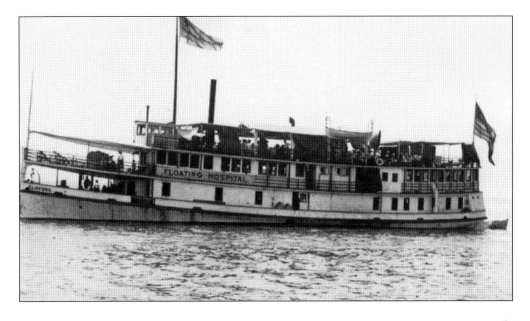

THE BABIES' OUTING.

A Day on the Floating Hospital on Its Second Trip Down the Harbor.

Pathetic Scenes Aboard the Big Barge---How Worn-Out Mothers and Sick Babies Are Tenderly Cared For by Physicians and Kind-Hearted Nurses---One of Boston's Most Beneficial Charities.

"God's noblest charity is fresh air and sunshine." Yes, and the babies got it on Tuesday. Not the sunshine, it is true, for unfortunately that is not made to or- breath must blow away, thrived under it and absolutely took on the hues of life again? Again? No, not again; some poor little weakling never had had any of the

The citizens of Boston greeted the idea of a hospital ship dedicated to the care and treatment of babies and children with great excitement and celebration. Out on the harbor, other ships sailed beside the Floating Hospital, blowing horns and waving to the passengers. It created a unique parade and was quite the spectacle. Local newspapers followed the daily voyages of the *Clifford* all summer and dedicated lead stories to "one of Boston's most beneficial charities."

BABIES' OUTING.

First Excursion This Season of Floating Hospital.

A SAIL DOWN THE HARBOR.

Eighty Passengers on Barge Clifford, of Whom Thirty Were Infants, Enjoyed the Trip—Stop Made Near Hull for Dinner.

HEALTH IN THE BREEZES.

First Harbor Excursion of the Season of the Floating Hospital.

People who take note of such things said last summer that when the Floating Hospital went down the harbor on its mission of healing it was always pleasant. So "Floating Hospital weather" became a familiar saying.

Today, for its first trip of the season, everything was equally propitious.

The tickets, which were distributed as usual, marked the time of starting as 9 o'clock; but it was much later when the boat got under way.

Manager Tobey this year has a goodly number of helpers, both lay and professional. Dr. Samuel Breck of Commonwealth avenue is at the head of the medical staff, and his helpers today were Drs. Burden, Price and Hargopian.

By the second year, the Floating Hospital's fame had spread across the country, and it was now looked upon as a Boston institution. The citizens of Boston were proud that their city had found a way to dramatically increase the number of children receiving quality medical care. Over the years, the outpouring of financial support for the work of the Floating Hospital enabled an ever-increasing number of voyages and care for the city's pediatric patients.

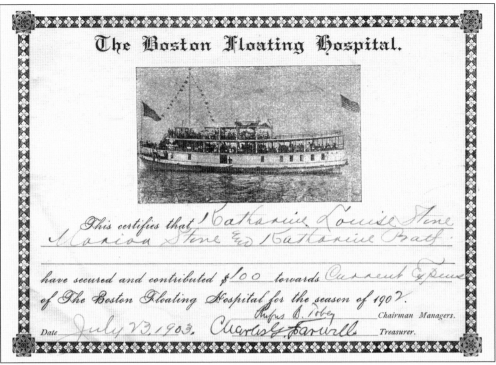

The Boston Floating Hospital.

This certifies that *Katharine Louise Stone Marion Stone & Katharine Pratt* have secured and contributed $100 towards *Current Expense* of The Boston Floating Hospital for the season of 190 7.

Date *July 13, 1903.*

Rufus B. Tobey Chairman Managers.

Charles G. Farwell Treasurer.

There were no fees charged for the medical care given on the Floating Hospital, so charitable donations to fund the daily voyages were necessary. One of the more successful ways to honor generous donors was to have a day, a room, or possibly a bed named for them, depending on the size of the donation. Pictured above is a receipt that documents a $100 donation in 1903 (about $2,500 today) that Tobey himself signed.

The majority of the Floating Hospital's expenses were covered by generous donations received from local charities. One group in particular, the Ten Times One Society, dedicated a large portion of its annual donations to the Floating Hospital. The leader of this Boston-based charity was Edward Everett Hale, better known for his literary works and most famously for his story "The Man Without a Country."

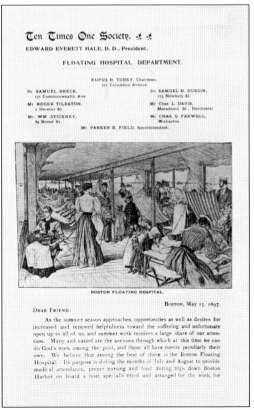

Ten Times One Society.

EDWARD EVERETT HALE, D. D., President.

FLOATING HOSPITAL DEPARTMENT.

RUFUS B. TOBEY, Chairman,
211 Columbus Avenue.

Dr SAMUEL BRECK,
172 Commonwealth Ave.

Dr. SAMUEL H. DURGIN,
175 Newbury St.

Mr ROGER TILESTON.
2 Decatur St

Mr Chas L. DAVIS,
Monadnock St , Dorchester

Mr. WM STICKNEY.
84 Broad St.

Mr CHAS. G FARWELL.
Wollaston.

Mr. PARKER B. FIELD, Superintendent.

BOSTON FLOATING HOSPITAL

BOSTON, May 15, 1897.

DEAR FRIEND:

As the summer season approaches, opportunities as well as desires for increased and renewed helpfulness toward the suffering and unfortunate open up to all of us, and summer work receives a large share of our attention. Many and varied are the avenues through which at this time we can do God's work among the poor, and these all have merits peculiarly their own. We believe that among the best of these is the Boston Floating Hospital. Its purpose is during the months of July and August to provide medical attendance, proper nursing and food during trips down Boston Harbor on board a boat specially fitted and arranged for the work, for

Over the years, the socially conscious and wealthy citizens of Boston successfully raised significant funds in support of the Floating Hospital. It was a source of pride and honor to be named as a major contributor to such a worthy cause. The article to the left from the *Boston Herald* tells of an 1897 charity gathering for the Floating Hospital at a "palatial residence" on the North Shore.

One fundraiser did not go well, however. A great scandal erupted when an event sponsored by a professional organization on behalf of the Floating Hospital was revealed to be a scam. Over $5,000 was stolen from the evening's proceeds. This incident marked the first and last time an outside group was given permission to raise money for the Floating Hospital.

No Contagious Diseases Admitted.

BOSTON FLOATING HOSPITAL.

SEASON OF 1896.

THE BOAT LEAVES SOUTH SIDE COMMERCIAL WHARF AT 9 O'CLOCK SHARP.

Date_____

Good only when signed by a Doctor who has seen the child, and upon the date specified by him.

Mother's Name_____

Address_____

Child's Name_____

Disease_____

Doctor's Signature_____

Trips will be made, weather permitting, on ▄▄▄▄▄▄▄▄▄▄▄▄▄▄

August 4, 7, 11, 14, 18, 21 and 26.

(OVER.)

No Contagious Diseases Admitted.

Because there were so many children needing medical attention and only a limited number that could be cared for on each voyage, a priority system was developed to identify the neediest patients. Red boarding passes were distributed by a welfare agency called Associated Charities that was dedicated to serving the poor. The admission tickets had rules and travel routes printed on the back. A doctor's signature verified that the child holding the ticket was sick and in need of medical attention but not contagious. These tickets were highly sought after and often determined the fate of many sick children.

No Contagious Diseases Admitted.

RULES to be strictly enforced.

1. Mothers must not bring food for themselves or the children, *any such brought will be taken from them.* The sick babies will be fed at regular intervals, and mothers and children will be furnished with dinner. Feed the child before leaving home.
2. If the mother has, beside the sick baby, a well child *under six years of age,* which cannot be left at home, she may bring one such child, *and one only,* if so specified by the doctor on this ticket.
3. If stormy on the day set for any trip it will be postponed to some date which will be given by the doctor or other person from whom you obtained your ticket.

ROUTES.

3. (a) The only car passing Commercial Wharf leaves Park Square running through Eliot and Kneeland Streets and Atlantic Avenue to Union Station and return, or

 (b) Take either a Washington Street or Tremont Street car marked East Boston. Get off at corner of Hanover and Richmond Streets, and walk down Richmond Street to Commercial Wharf, South side, or,

 (c) Take any Rowes Wharf car, and walk from where it leaves you to Commercial Wharf.

PARKER B. FIELD, Supt.

(OVER.)

No Contagious Diseases Admitted.

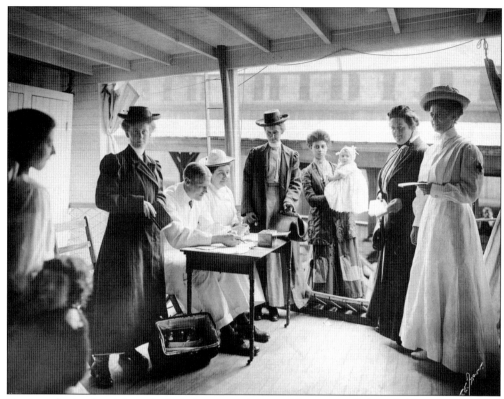

Having obtained a ticket of admission, a mother would arrive with her child at the Atlantic Pier gangplank by 9:00 a.m. Once there, she presented the ticket and had her child registered by the medical inspection team. An initial review of the child's illness was conducted, along with necessary questions to confirm that he or she was not contagious. An additional part of the entry process included a check to see whether the mother had brought any food with her. Outside food was prohibited in anticipation of the child's treatment because it might not be as wholesome as the food that was provided on board.

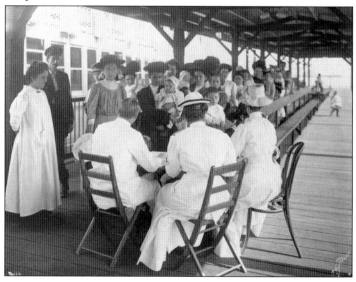

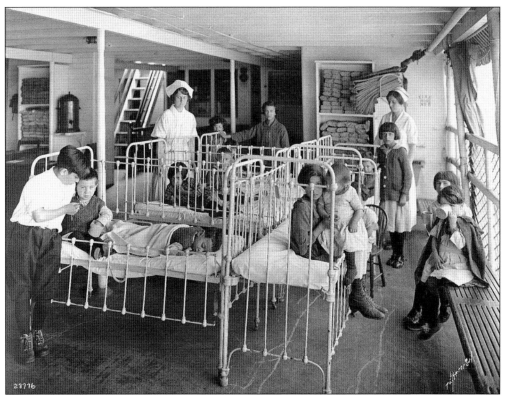

In a unique departure from the established practice at the time of separating patients from family members, mothers were welcomed to stay on board and help in the treatment process. Soon the mother's presence was deemed essential to successful medical outcomes. In another first, mothers were allowed to bring along one sibling under the age of six for the day. Not having to find day care for a brother or sister of the infirmed meant that more mothers could take advantage of the benefits a day on the ship could provide. Siblings were cared for by specially trained staff and given a healthy meal at lunchtime.

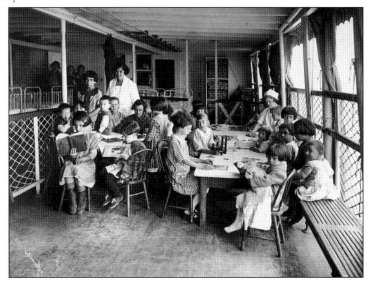

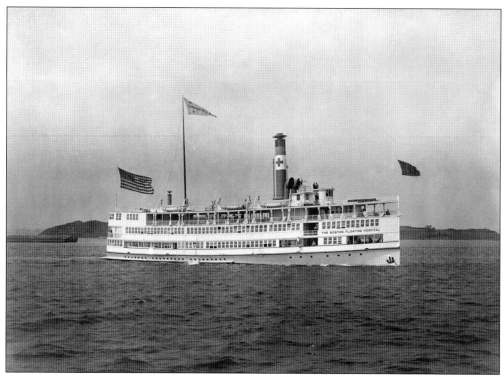

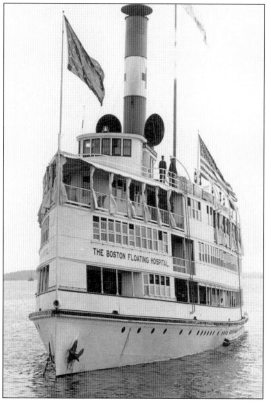

Weather permitting, the Floating Hospital would sail out on the Boston Harbor twice a week. On average, over 200 sick children, with their mothers and siblings, were on board for each day's voyage. At the end of the day, all sick children were sent home or, if further treatment was necessary, to another facility, usually Boston Dispensary. Later, especially when the new Floating Hospital was in service, arrangements were made to have some patients stay on board overnight.

Dr. Henry Bowditch, physician in chief from 1906 to 1925, is credited with seeing that the Floating Hospital achieved and retained its role as the national leader in pediatric medicine. He was an outstanding doctor who had a knack for pediatric diagnosis and an instinct for successful treatments. A great teacher, he instructed his students and interns to "first look in their ears" when making a diagnosis of a pediatric patient.

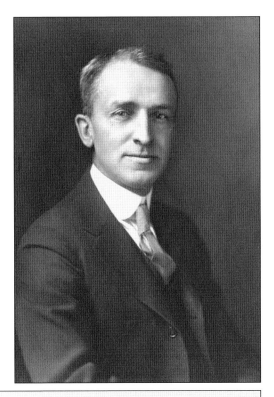

In this photograph of the Floating Hospital's founders, Dr. Simon Flexner (seated second from left), who conducted research at the Floating Hospital in 1903, is pictured with the Reverend Rufus B. Tobey (seated at left), the hospital's architect, and Dr. Samuel Breck (seated at right), chief of the visiting medical staff, who were mostly from the Boston Dispensary. By then, the Floating Hospital's reputation had drawn many dignitaries to visit, including the standing row of gentlemen from the Boston Board of Health.

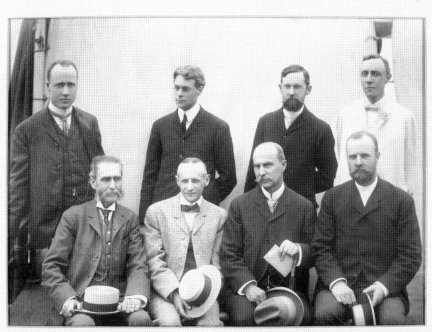

Standing: Hibbert J. Hill
Arthur J. Kendall, Ph.D.
William E. Foy, M.D.

Sitting: Rev. Rufus B. Tobey
Simon Flexn
Samuel N. Du

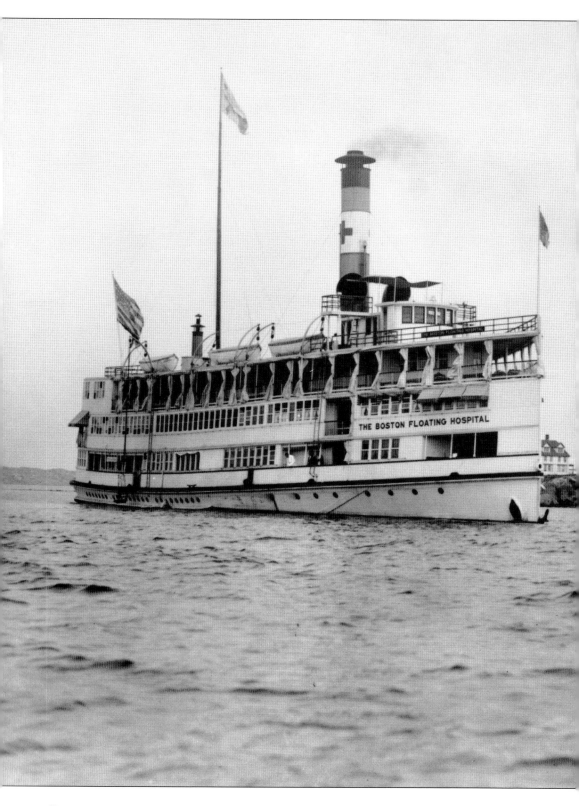

THE BOSTON FLOATING HOSPITAL

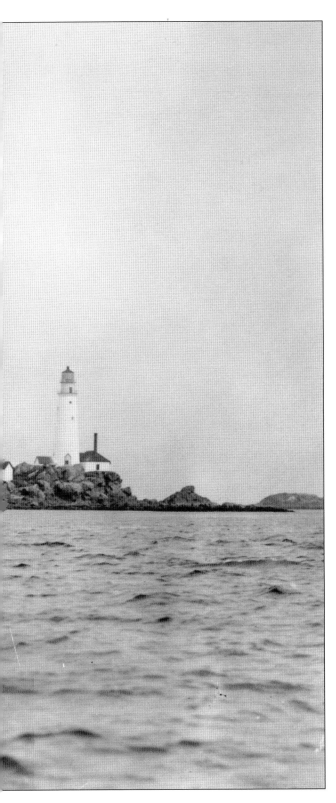

Lewis Freeman described a typical day's voyage in his journal: "We'd go out whenever there was a breeze. We'd leave the North End Pier at 9 in the morning; go out into the upper harbor, then into the lower harbor and down to Long Island opposite Deer Island. If the breeze got too heavy we'd turn around and come back into Dorchester Bay and anchor down off Thompson's Island. On Sunday we'd go through Hull Gut and anchor off Pemberton. Sometimes, if the air was just right, we'd travel up to Marblehead or go down to anchor off Situate Light. But our favorite spot to anchor and have lunch was just off Boston Light. The lighthouse keeper would sound the foghorn in our honor and the children would wave back."

From the first voyages of the Floating Hospital, there were classes to teach mothers how to better care for their children. The objective was to place responsibility for the long-term follow-up care of the children on the mothers so their children would continue to get better and not have to return to the hospital. An equally important and revolutionary function of the hospital staff was to show the mothers how preventative steps taken at home, such as keeping food from spoiling and proper housekeeping, could prevent siblings from contracting some of the many illnesses plaguing children at the time. While on board, the doctors and nurses also held formal classes to educate mothers about food nutrition and how to care for children in the early stages of an illness. The result, as seen above, was happy mothers and happy children.

Spoiled milk was one source of infection in children and the primary cause of cholera infantum. Milk, the most essential nourishment for babies and small children, was not safe to drink for many reasons. The value of pasteurization was not recognized until after 1908, and living conditions in this period of no refrigeration contributed to milk being unsafe to drink. Little had been done to educate parents about how to keep milk from going bad, so other than sterilizing cow's milk, only mother's milk was considered safe for babies and small children. The mothers pictured here are learning how to sterilize milk.

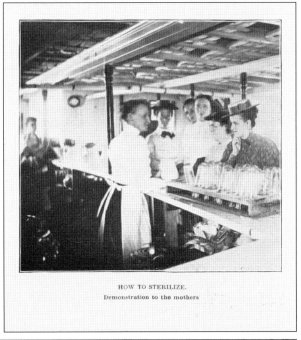

HOW TO STERILIZE.
Demonstration to the mothers

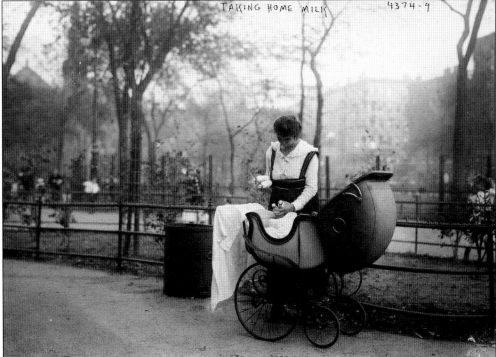

Because so many babies and young children were on the ship each day, the need to collect a large supply of fresh mother's milk became a citywide campaign. In the first effort of its kind, the Floating Hospital established a milk bank. Special teams of the hospital crew went out into the city's neighborhoods daily and brought back gallons of mother's milk for that day's sick children. Pictured is a mother with a day's supply of milk.

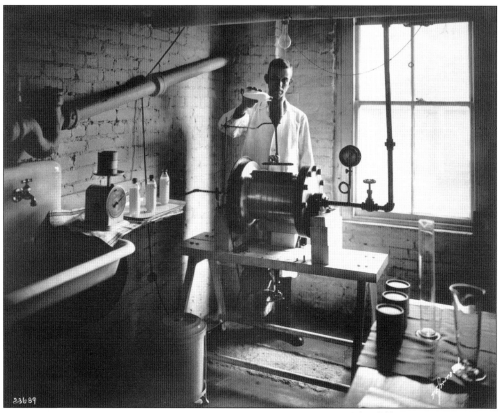

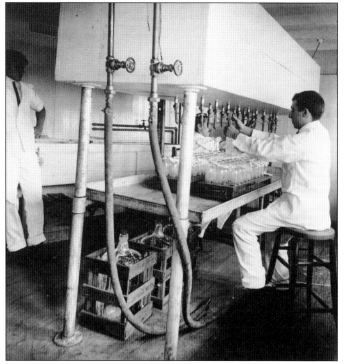

The following is a passage from Lewis Freeman's journal: "A nurse from the On-Shore clinic would go out each day and find new mothers who had too much breast milk or had lost their baby and she would collect the excess breast milk. Dr. Larry Smith [pictured above] had this machine where he would take the [donated] milk and powder it. And when we had a preemie or some baby with nutritional defects that needed breast milk, all we had to do was take the powder, reconstitute it and we had breast milk again." At left, crew members are bottling previously powdered breast milk.

Drinking cow's milk alone often resulted in a variety of intestinal difficulties for babies. Research conducted at the Dispensary's food laboratory convinced Dr. Francis Denny that adding even a small amount of breast milk to the formula of sick infants was beneficial because of its antibacterial power. But as mother's milk was often in short supply, a substitute system was needed. In 1914, Dr. Denny recruited Dr. Albert Bosworth, a chemist, to establish a laboratory at the Floating Hospital solely for the purpose of developing a formula that could be used as a supplement for mother's milk. Dr. Bosworth's research and testing resulted in a powdered milk product that reorganized the elements of cow's milk in proportions nearly identical to breast milk and, after being mixed with water, was safe to drink. In an unfortunate financial decision for the hospital, the trustees relinquished its patents on the formula at no charge. The product, which was eventually named Similac, is still being sold today. The date of this advertisement announcing Similac is unknown.

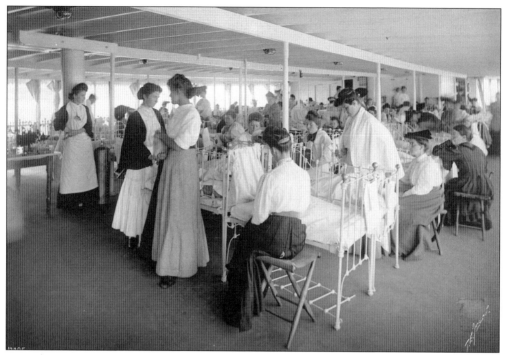

From the very first voyage of the *Clifford*, during which three nurses were on board, nurses played a critical role in the success of the Floating Hospital. Although doctors and residents were in place, mostly for their diagnostic role, it was the nurses who provided the medical and nurturing care that was the hallmark of the Floating Hospital. Student nurses were housed on board the ship and on land at the Maverick Home in East Boston.

Boston Floating Hospital.

THE FLOATING HOSPITAL COMMITTEE

Desires to express its appreciation of the volunteer services of nurses (chiefly graduates) in the past, and again appeals to those formerly so connected with the Hospital and to other nurses for help during the coming season.

T rips will be made four times weekly during July and August of this year.

Any nurse wishing to make one or more trips at any time when disengaged during these months will kindly send her name and address to the undersigned as soon as convenient.

SAMUEL BRECK, M. D., *Medical Director.*

April 26, '97. 172 Commonwealth Avenue.

Pictured is an 1897 flyer soliciting nurses for the following summer's voyages aboard the Floating Hospital. The committee especially sought those with a nursing degree who had served on the ship in the past. It was a very prestigious assignment. Nurses came from all over the country to serve on the Floating Hospital.

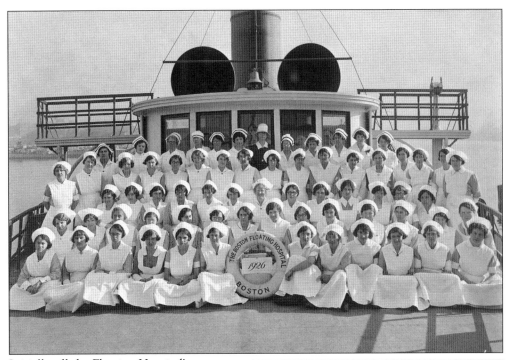

Initially, all the Floating Hospital's volunteer nurses were trained to work with adults. As their duties evolved and grew, specialized training and certification became necessary. By 1900, all nurses working for the Floating Hospital were graduates of nursing school and had specific training in pediatric care. To ensure a full complement of appropriately trained nurses, a graduate school was established aboard the Floating Hospital. The yearlong program was the first to specialize in the care of infants and preemies. Pictured above is the graduating class of 1926.

The following is an excerpt from "A Day on 'The White Ship of Mercy,' " published in *The Nurse: A Monthly Journal of Practical Knowledge* in January 1917: "In ward instruction, the nursing students are taught hospital bed making, preparation of beds for premature infants, bathing, feeding, irrigations, etc. In the classroom, the nurses are given instructions in printing, uniform charting, arithmetical processes of computing formulae for percentage feeding, making premature jackets, preparing solutions for infusions and other details of infant nursing."

The first medical crew aboard the *Clifford* was an all-volunteer staff that included two physicians, several medical students, and three nurses. The doctors examined the children, assessed a diagnosis, and recommended a treatment, leaving the actual administering of medical care to the nurses and resident staff. As time went on and the numbers of children and illnesses treated increased, the medical staff grew quite large but stayed in relatively the same proportions. A group of medical crew members and patients is pictured aboard the Floating Hospital.

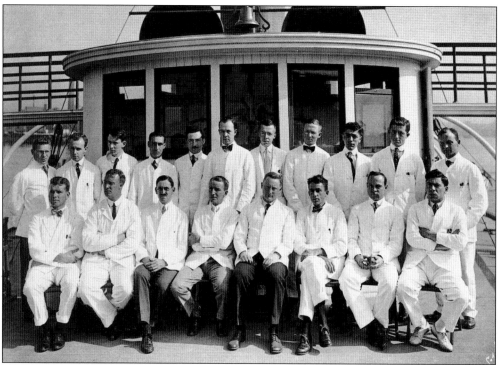

The Floating Hospital's doctors initially came from local medical centers, especially the Boston Dispensary and Harvard Medical School. But as the reputation of the groundbreaking work on pediatric illnesses became known, doctors from around the country vied to be chosen to serve as volunteers on board the Floating Hospital. The doctors consisted of two groups: attending faculty physicians, who only came on board briefly to see and diagnose patients, and resident doctors, who actually prescribed and administered treatments. Pictured are the doctors who served in the summer of 1925.

By 1902, the need for a larger dedicated pediatric hospital ship had become evident. The *Clifford* was stretched beyond a reasonable capacity and could no longer service all the needs of a growing patient population. More day beds were needed, overnight patients required accommodations, and additional research space was in desperate demand. Plans had begun for the construction of a new ship, but as there was little money available, the *Clifford* was kept in service for four more years.

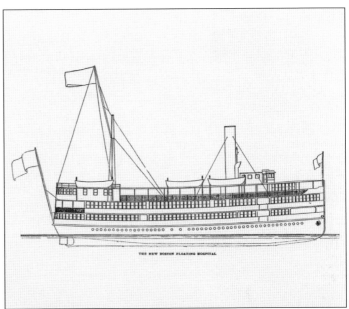

THE NEW BOSTON FLOATING HOSPITAL

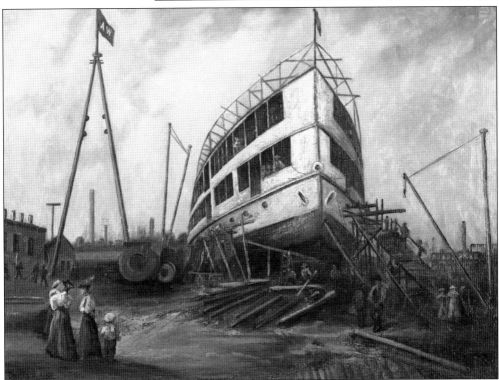

Finally, in 1904, the Floating Hospital commissioned the much-needed larger ship, which was built to accommodate its unique specifications. It was the first vessel ever constructed for the express purpose of being a hospital ship. It was designed not only to meet current needs but also to be flexible enough to adapt to the future. It was to be the model for all such ships that might succeed it, although none ever did. Pictured is a drawing of the ship under construction at the Atlantic Works in East Boston.

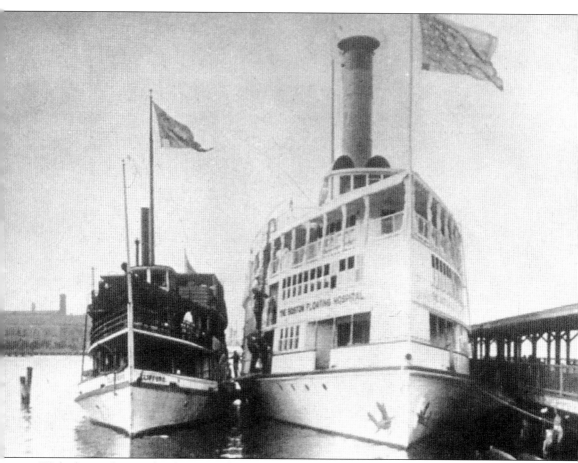

With the newly completed Boston Floating Hospital ship now ready for service, the big day of relocating operations from the *Clifford* was at hand. Having served in a historic and groundbreaking role for 12 years, yet soon to be deserted, the *Clifford* made its last voyage on August 14, 1906. It returned early enough that day to allow the entire assembly of crew, house staff, and medical personnel to transfer all of the *Clifford*'s equipment and supplies to the new ship before the end of the day. The torch had been passed from the much-heralded *Clifford* to the new Boston Floating Hospital for Children. A new era had begun. The two ships are pictured side by side on moving day.

Highly prized invitations were issued to special guests to join each day's excursion, which included a complimentary lunch. Guests were most often dignitaries, visiting doctors, and most importantly, current and potential donors. One special guest of the Floating Hospital was little Frank Spolidoro, who went on every trip with his fiddle "to make sweet music and earn a few pennies." According to *The Babies' Outing* of July 1895, he was said to be "adorably pretty with the saddest gray eyes and pathetic mouth and the seraphic expression of a dark-haired cherub." This photograph was often used for fundraising purposes, as it demonstrated the important fact that the Floating Hospital did not discriminate which patients it served. All races and creeds were welcomed aboard. Pictured are a guest voucher for a complimentary lunch and a photograph of Spolidoro and his audience of one, Arthur Simpson, a patient on the Floating Hospital.

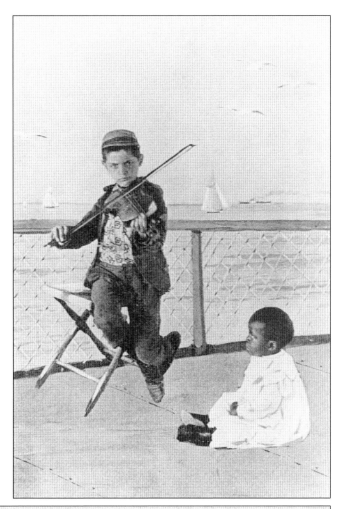

BOSTON FLOATING HOSPITAL.
Season of 1895.
Good for One Lunch.
Upper Deck.

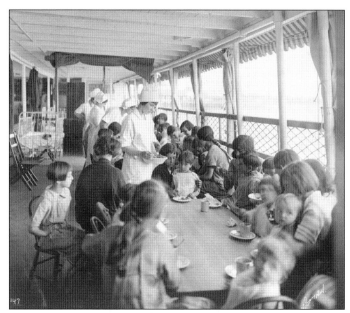

One of the guidelines strictly enforced aboard the Floating Hospital prohibited the mothers from bringing any food or drink with them when they sailed. The medical personnel was highly suspicious of any food not prepared by the ship's staff. They wanted the children to eat only the quality and wholesome food that was served fresh each day. Pictured are children having their lunch on the ship's open deck.

Sylvia Bacchini, who worked in the linen room from 1914 to 1917, wrote the following journal entry: "The food that was served in the mother's dining room [pictured] was wonderful and better than most had in their own homes. Mrs. Volpe was the cook; she had six girls working under her. The kitchen on the boat had those old black stoves. Breakfasts were wonderful, eggs, bacon and Mrs. Volpe's own muffins."

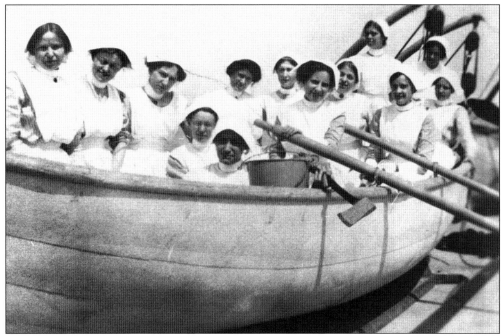

The ship's emergency procedures are described in the January 1917 edition of *The Nurse* as follows: "Daily, during the quiet of mid-afternoon an interesting diversion occurs, a diversion unheard of in ordinary hospital life. The fire alarm from the steam whistle summons the entire crew including the medical and nursing staffs to their fixed stations for the various lifeboats with which the vessel is amply equipped. The boats are hurriedly swung out and lowered by the crew and physicians under the command of the vessel's officers. When all are lowered, the nurses enter the life boats and instruction is then given in passing infants to the nurses by the use of bundles instead of the actual little ones. In two minutes after the alarm has been sounded, the boats have been manned and are afloat with staff, nurses, and crews and make believe babies."

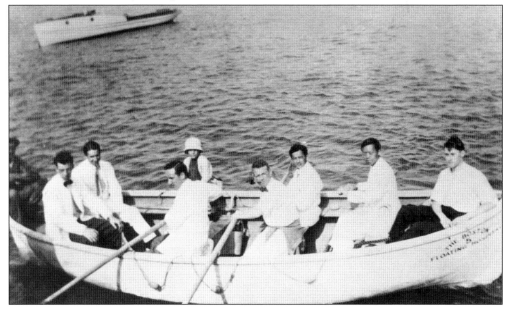

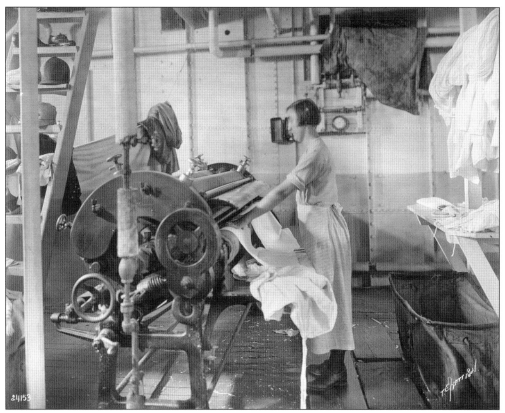

Each day, over 1,000 diapers were made for the young patients, and each day, all were discarded for sanitation purposes. In addition, daily sterilization of all 3,000 pieces of linen was strictly enforced. During the summer season of 1901, not a single case of infection was contracted aboard the Floating Hospital. Victoria Moro Connor described the experience of her mother, Sylvia Bacchini, who worked in the linen room from 1914 to 1917: "Being on the Floating was one of the happiest times of her young life. She just loved it. She had charge of the linens, distributing them, mending them, etc." These photographs depict the laundry and linen rooms.

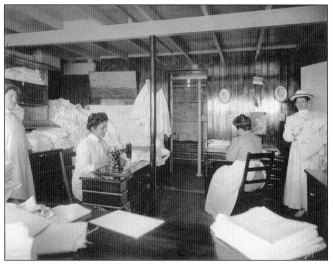

Life preservers became the unique symbol and marketing piece of the hospital. It became a regular event to have healthy children pose with them. The photograph of the boy was taken aboard the ship, and that of the girl was taken years later, even though by that time the Floating Hospital had moved on land to the Jackson Building at 20 Ash Street. From the beginning, one of the factors that went into the growth of the Floating Hospital was its ability to market its programs and successful medical outcomes. Name recognition and a well-earned national reputation resulted in large donations that went toward operating expenses and funding for research of childhood diseases.

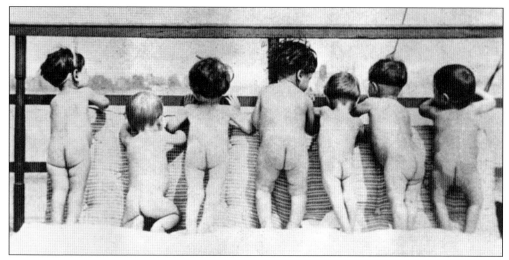

According to Lewis Freeman's journal, "We'd take some mattresses up to the hurricane deck and then we'd bring the babies up with nothing on but a hat on their head. And we'd expose them to the direct rays of the sun for a measure of time for the treatment of rickets."

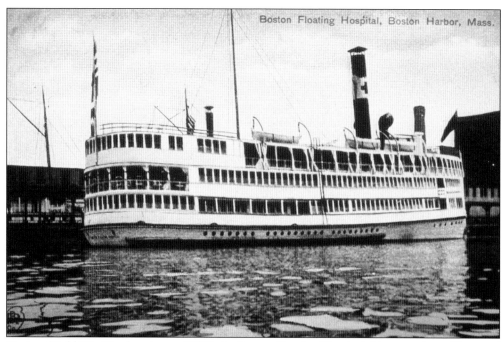

Boston Floating Hospital, Boston Harbor, Mass.

During World War I in the winter of 1918, the Boston Floating Hospital ship was taken off hospital duty and commissioned as the USS *Boston Floating Hospital* to serve as a naval dormitory. When the need for temporary housing for the sailors ended, it was retrofitted as a hospital ship and made ready in time for the following summer's voyages.

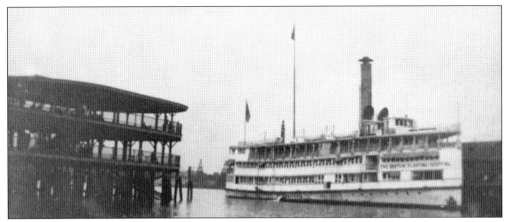

Despite the benefits of Boston Harbor's cooling sea breezes, the Floating Hospital was often still too hot in the summer to make the patients comfortable. This recurring problem led the board of directors to incorporate a hospital-wide air-conditioning system (similar to one used by a local candy company) in 1899. The Floating Hospital was the first ship of any kind in the country to have air-conditioning. The positive effect of having an air-conditioned space was immediately apparent and allowed the ship to sail in even the hottest weather. Installing air-conditioning was just one of the many accommodations and innovations that having a children's hospital on a boat necessitated.

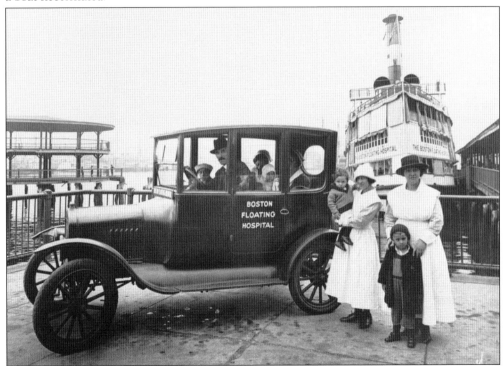

This 1924 photograph shows Floating Hospital founder Rev. Rufus Tobey manning the shuttle service. On this day, he took children with whooping cough, along with their mothers and nurses, from the ship to its onshore hospital located on Wigglesworth Street. From its simple initial mission of giving babies and small children an opportunity to receive primary medical attention, the Floating Hospital was developing into a full-service pediatric medical complex.

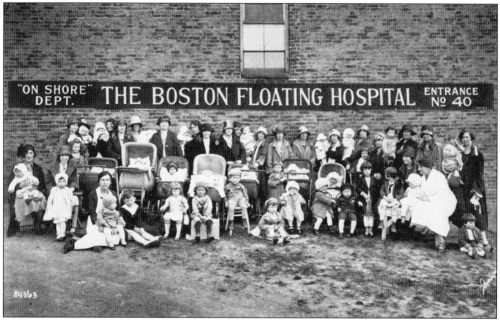

In 1916, the Floating Hospital established the first of its many on shore departments. Initially, these departments were set up to serve as research facilities that could not be housed on the ship, but by the mid-1920s, the Floating Hospital had established an inpatient onshore facility at 40 Wigglesworth Street. With a much larger inpatient capability, the on shore department was able to serve children with longer-term medical needs that could not be met aboard the ship. The two 1923 photographs show patients and their mothers dressed for winter and waiting to be seen at the on shore department.

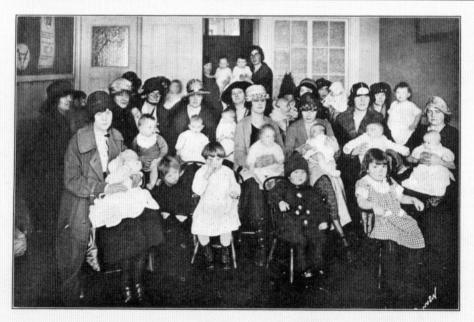

OUT PATIENTS' CLINIC AT "ON SHORE" DEPARTMENT

In 1910, a volunteer ladies committee of seven women was founded as an operational advisory board for the Tyler Street Day Nursery. By 1912, the committee, with the nursery now part of the Boston Dispensary, had been enlarged and authorized to provide a wide range of services for the betterment of the hospital. The Ladies Committee was now charged with fundraising, facility upkeep, inspections, linens, furnishings, visitors, publicity, social services, volunteers, and nursing education. By 1928, it had also became responsible for running the thrift shop and entertainment (mostly guest speakers). Many considered the committee to be the heart and soul of the hospital. Its membership was comprised solely of female volunteers, many of whom were wives of doctors. After the committee disbanded in the 1990s, its duties and diverse functions were spread among multiple hospital departments. Here, committee members are shown with the activity and print carts.

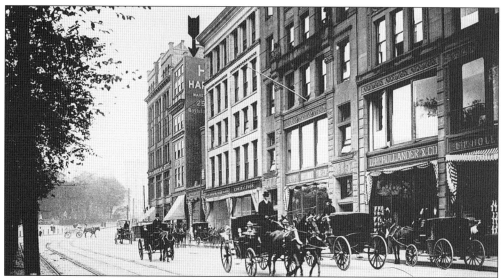

Tufts University School of Medicine (indicated by the arrow) was founded in 1892 with an initial class of 22 students, eight of whom were women (five of whom are shown at left). From the school's beginning, its students served and studied at both the Boston Dispensary and the Floating Hospital for Children. Initially housed on Boston's Boylston Street, it later moved to the South End so that it would be near the Dispensary and Pratt Diagnostic Clinic. In 1929, Tufts School of Medicine, along with the Pratt Clinic, joined in a formal affiliation with the Dispensary and the Floating Hospital. Over the years, the relationship between the hospitals and the university has grown and continues to be so strong that the hospital is now known as Tufts Medical Center, the primary teaching hospital of Tufts University.

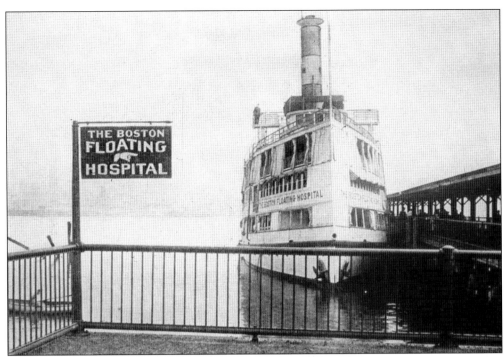

On June 1, 1927, after just being outfitted for the coming summer's voyages, the Boston Floating Hospital ship was brought to its dock at the North End Park pier. That night, a fire of unknown origins broke out on the pier and quickly spread to the ship. By the time firefighters arrived, flames had totally engulfed the ship and burned to the waterline of the ship's steel hull. It was a total loss, but through fortuitous foresight, the ship had recently been insured for $250,000. The insurance money was used to help build a new facility and to keep the important work of the Floating Hospital going. The photograph above and the painting at right show the ship docked at the North End Park pier.

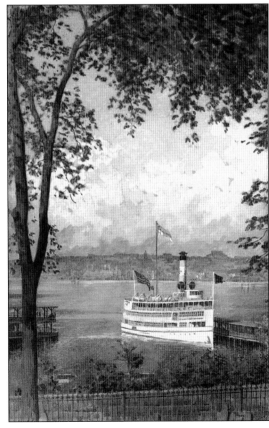

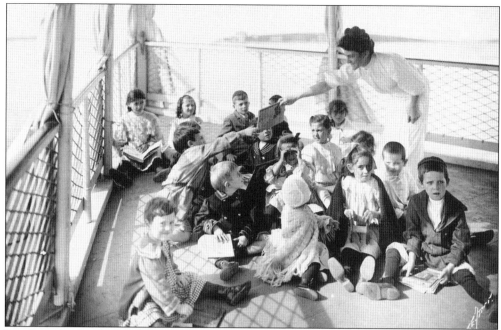

In a first of its kind, a kindergarten was established on the top deck of the ship. It was created to accommodate siblings of the infirmed who had come aboard, so the mothers could tend to the needs of their sick children. Later, the sick children, if appropriate, could join their siblings in the kindergarten. This awareness and attention to the "whole child," including the nonmedical, educational, and social needs of pediatric patients, was a groundbreaking innovation that eventually lead to the formal creation of what is now the Floating Hospital's Child Life Services. The kindergarten teacher pictured is Ellen Field, the superintendent's wife.

As part of the ongoing effort to make the hospital experience as nonthreatening and normal as possible, children were allowed, and in fact encouraged, to participate in a diverse number of activities. The pediatric patients pictured here are taking advantage of the outdoor play area of the Jackson Building.

The Ace Bailey Children's Fund was established in memory of Garnet "Ace" Bailey, a member of the 1970 and 1972 Boston Bruins Stanley Cup teams who was aboard United Flight 175 on September 11, 2001. Headed by his wife, Katherine, and sister Barbara Pothier, the fund is supported by the many people Ace touched during his life. With the initial $1 million raised by the foundation, the Floating Hospital revitalized its existing play area, created an arts and crafts space, and filled the room with new toys, a pool table, and comfortable couches from which parents can observe their children laughing and having fun. Ace's Place, as it is known, is a real oasis for these children and their parents. The play area is another piece of the hospital's special "whole child" mission.

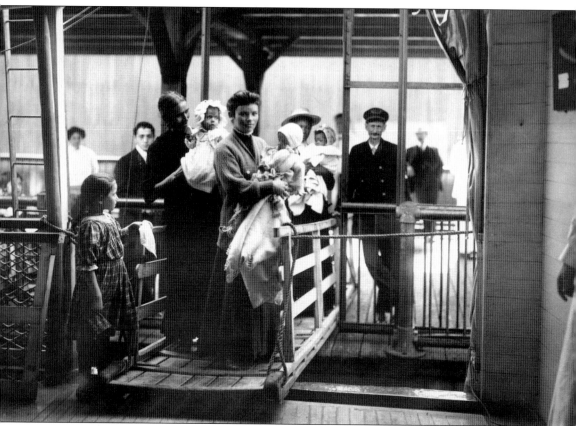

Having parents involved and even participating in the care of their sick children has been the pride of this family-friendly institution since its inception. Prior to the Floating Hospital, parents of pediatric patients were excluded from the care and treatment of their children. In fact, the medical profession considered parents not educated enough, in the way, and often part of the problem. But because mothers logistically had to be on board the ship with their sick children, their presence was initially tolerated, and in a short time, they were regarded as a tremendous help in medical communications, as well as comforting the young patients. The mothers were also educated on how to care for their child once they were back home. This partnership is still a proud hallmark of the Floating Hospital today.

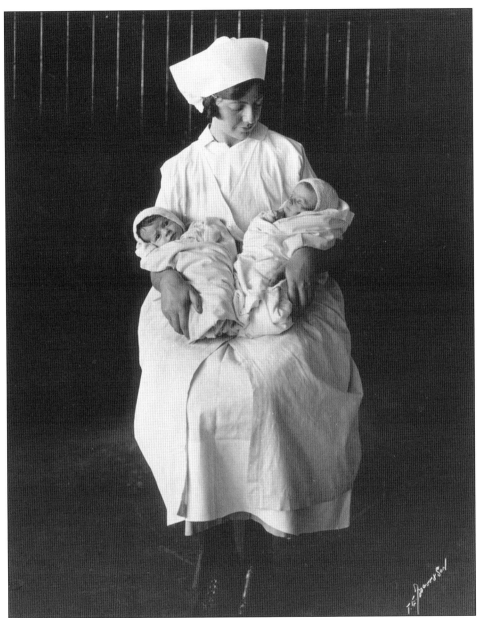

The role and status of the Floating nurses continued to grow and evolve over the years. By the time of their service in the Jackson Building, they had taken the lead in treating the pediatric patients as children first, then as children with a medical condition. While maintaining the highest standards of medical care, they began to break down some of the rigid nursing formalities in vogue at the time. Some outward changes, such as wearing more casual and comfortable uniforms and being called by their first name, were practical and welcomed by all. Other, more subtle changes affected how they viewed their relationship with the patients and their families. They learned that being more nurturing and approachable made a noticeable difference in a positive and successful medical outcome. This nonthreatening and cheerful atmosphere, which is still quite evident at the Floating Hospital today, allows for a better, more natural relationship with the children and their families.

Tufts Medical Center's Department of Child Life Services was initiated in 1948 as one of the nation's first hospital-based activity programs for children. The pediatric social services center was designed and implemented to help patients and their families cope with the stress of illness, injury, disability, and hospitalization. The department is responsible for maintaining the playroom known as Ace's Place, providing diversionary activities and events, and having a strong presence in the pediatric emergency room. Child Life Services continues to be a major contributor to the hospital's "whole child" mission.

In 1963, the original Family Participation Unit was formed. This facility allowed parents to stay overnight with their sick children. This innovative program continues to foster greater participation and communication between the medical staff and families, resulting in more effective and efficient treatment outcomes. Variations of the Family Participation Unit are now the norm at children's hospitals nationwide.

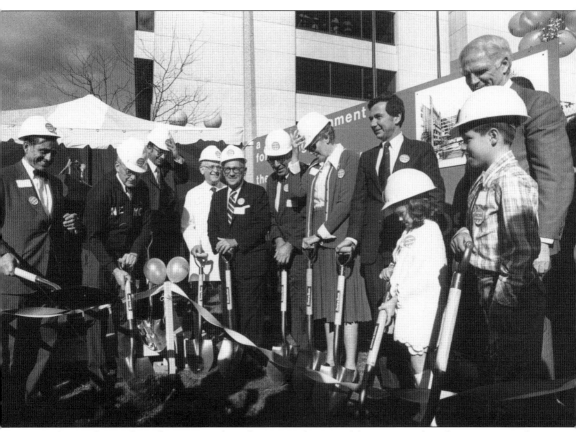

The need to replace the aging and inadequate Jackson Building was evident for many years, but financing and other priorities continued to curb the effort. So it was with great joy and anticipation that a commitment to build a new Floating Hospital for Children and to continue its historic mission was finally made in 1977. The move to the new building took place in 1982. The state-of-the-art facility was designed to maximize the services and programs the Floating Hospital was known for. Pictured at the ground-breaking ceremony are, from left to right, William Saltonstall, chairman of New England Medical Center (NEMC) Board of Governors; Franklin Parker, member of the board; Marvin Stiflinger, US Department of Health, Education, and Welfare; Dr. Samuel Proger; Dr. Jean Mayer, president of Tufts University; Dr. Sydney S. Gellis, pediatrician in chief; Geneva Katz, former Floating Hospital administrator; Dr. Jerome H. Grossman, president of NEMC; Kevin H. White, mayor of Boston; and April Murphy and Lee Stimson, former pediatric patients.

Three

TUFTS MEDICAL CENTER

In 1946, the Boston Dispensary issued a booklet titled *150 Years: A Good Samaritan* in commemoration of the 150th anniversary of its founding. It briefly recounted the history of the institution, highlighting many of the people and innovations that were instrumental in contributing to its legacy and longevity. The hospital could have rested on its laurels, content to let past successes speak to its future. But no institution can continue to exist assuming that what worked before will continue to work. Understanding this basic tenet, the booklet's authors spoke of the challenges that they faced soon after World War II. They noted the demand for special equipment, increasingly expensive laboratory procedures, and the need for more beds for diagnosis and treatment.

As forward minded as they were, it is doubtful that they, or anyone, could have foreseen the magnitude and speed of changes in medical care that have actually occurred. Some of the advances must have seemed like science fiction in the 1940s. For example, the polio vaccine, heart transplants, and infusion centers now exist; surgery is now laparoscopic, computer assisted, and robotic; and MRIs, CT scans, and colonoscopies are now routine.

As this chapter shows, there is very little resemblance between the medical care of the 1930s and that of the 21st century. Tufts Medical Center continues to embrace the need to change with the times, but certain basic principles persist and explain why the hospital is well into its third century of operation. The closing remarks of the 150th anniversary booklet aptly sum up these principles: "To provide for community needs, to take advantage of developments in the fields of medicine and surgery, to continue to be a Good Samaritan in service to the needy—these are the aims which the Dispensary will earnestly endeavor to fulfill." These words apply as much today as they did in 1796 or 1946, and hopefully, they will still hold true on the 300th anniversary of the hospital in 2096.

This 1973 photograph shows a kidney dialysis machine that had evolved from Dr. William Kolff's original 1940s version. In the 1970s, dialysis was still in its medical infancy. Dialysis removes waste and excess water from the blood. It is used as an artificial replacement for patients with lost renal function. It is now one of the most common procedures in US hospitals and outpatient clinics.

Experimentation with radioactive iodine for the treatment of thyroid problems began in the late 1930s. In this early 1940s photograph, a New England Medical Hospital laboratory technician is using a Geiger counter in the endocrinology laboratory. The test subject is a white rat. Geiger counters are still used today as a tool to detect the level of radioactive iodine during treatment of thyroid cancer.

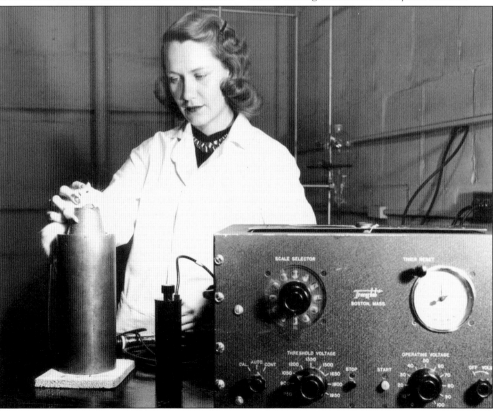

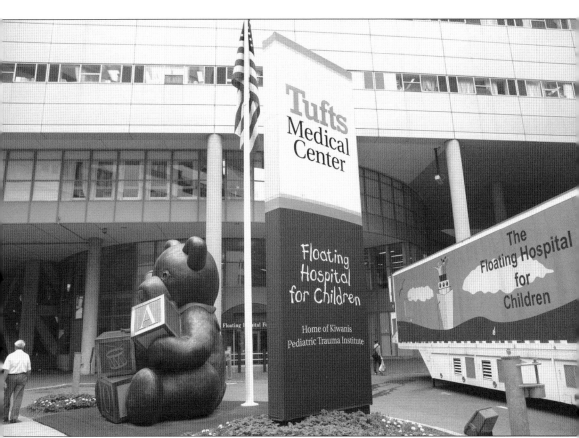

Tufts Medical Center is the proud descendant of a succession of various medical institutions and names. It started with the Boston Dispensary in 1796. Then the Floating Hospital for Children was established in 1894. In 1929, these institutions affiliated with Tufts University School of Medicine to form the New England Medical Center. The Pratt Diagnostic Hospital, built in 1931, became the fourth unit of the New England Medical Center. When the Farnsworth Building opened in 1949, the Pratt name was changed to the New England Center Hospital. The similarity between this name and the New England Medical Center caused confusion. So it was renamed the Pratt Clinic–New England Center Hospital, which did not do much to clarify things. In 1965, when these affiliated institutions merged, they adopted a single name—New England Medical Center Hospitals. To emphasize the unity of the individual components, the name changed to New England Medical Center in 1981. Two recent changes recognize the long and close relationship with Tufts Medical School, first by adding Tufts to the name (Tufts–New England Medical Center), then lastly in 2008 to what it is today: Tufts Medical Center.

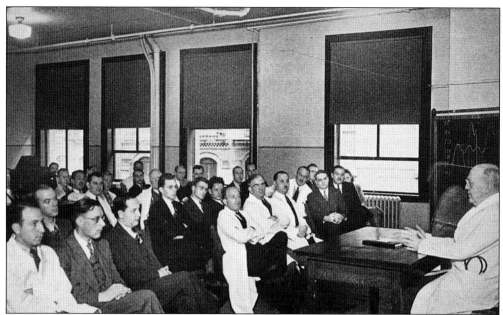

In 1905, Dr. Joseph Pratt began his class method of treating tuberculosis, using a form of group therapy to teach his patients how to cope with the disease. He required his patients to sleep on the roofs of their homes to get as much fresh air as possible. He believed that, with strict adherence to his rules, patients could recover at home as well as at an institution. Dr. Pratt arrived at the Dispensary as physician in chief in 1927. In the 1930s, he developed a class called Thought Control, a pioneering venture in group psychotherapy, at the Dispensary. He is often considered "the father of modern group therapy in America." Above, Dr. Pratt is seen instructing members of the hospital staff in the 1930s. Below, a doctor is teaching a class in applied psychology in 1948. Boston University Divinity School professors assisted in conducting the class.

The Pratt Diagnostic Clinic began in 1931 as a 20-bed diagnostic ward within the Dispensary. It was so successful that, in 1938, a 100-bed facility was constructed on the Bennett Street site of the Franciscan Monastery of St. Clare, along with several adjacent tenements. At the time, it was the largest hospital in the country constructed solely for diagnostic purposes. Its focus was not to be a general hospital but rather to assist in diagnostic techniques and diet regimen. For a brief time in the mid-1940s, surgeries were performed in a small operating room in the basement of the building. Dr. Pratt created the Department of Surgery in 1946. In 1948, the Pratt Diagnostic Clinic became an integral part of the newly named New England Center Hospital. On his 80th birthday, Dr. Pratt gave this advice to young doctors: "Never forget that patients are persons . . . you cannot treat your patient without considering his emotional life." Dr. Pratt is pictured below, and to the right is the main entrance to the Pratt Building in 1938.

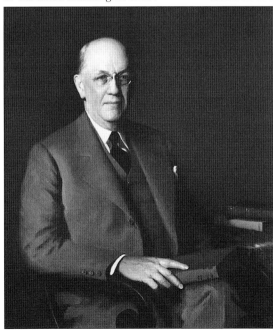

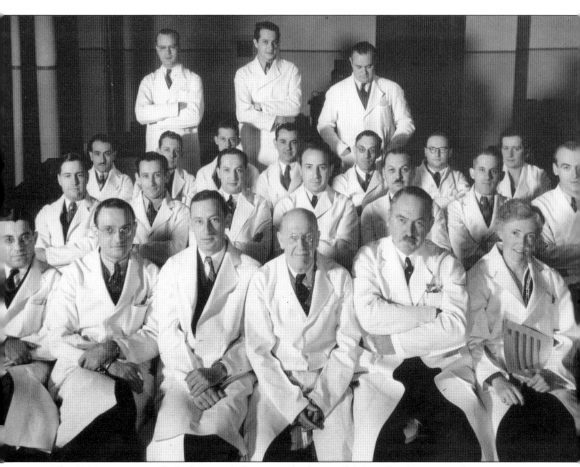

The 1930s was a period of substantial change at the hospital. Major fundraising endeavors, mergers, and new buildings led the way. For the first time, operational departments such as purchasing, accounting, and housekeeping were centralized. By the end of the decade, over 228,000 patients had visited either the day or evening clinics or were seen by a district physician. During the same period, the pharmacy wrote nearly 68,000 prescriptions. Although no single factor can explain why the institution grew so rapidly, what stands out is the expertise and experience of the physicians. This c. 1937 photograph shows the Dispensary medical staff. Included are several of the doctors who had just escaped from Nazi Germany: Dr. Siegfried Thannhauser (first row, fifth from left), Dr. Heinz Magendantz (second row, sixth from left), Dr. Heinrich Brugsch (third row, second from right), Dr. Anna Reinauer (third row, far right), and Dr. Jacob Schloss (fourth row, standing at right). Also pictured in the first row are Dr. Samuel Proger (second from left) and Dr. Joseph Pratt (fourth from left).

Occupational therapy as a profession gained prominence during World War I, partly in response to the overwhelming number of injuries resulting from the conflict. The first practitioners were called reconstructive aides. The philosophy behind the therapy was that a meaningful occupation could help cure a myriad of mental and physical problems. Now, licensed occupational therapists assist people of all ages to participate in the things they want and need to do through the therapeutic use of everyday activities. They help recovering patients regain the skills needed to be independent again. In addition to inpatient therapy, their services include family education. They also focus much of their work on identifying and eliminating environmental barriers to independence and participation in daily activities. At right, patient Eddie Stone, a jeweler by trade, works on his latest creation. Below, an unidentified patient works at a printing press in the occupational therapy shop.

In 1935, Dr. Samuel Proger successfully treated the life-threatening thyroid condition of Cameron Biewend and, in turn, won the lifelong appreciation and financial support of this industrialist. Biewend's relationship with the Medical Center was extensive. He served on the hospital's board of governors and was instrumental in putting the hospital on a sound financial track. What he is most noted for, however, is contributing the down payment to purchase the nearby Metropolitan Building when it came up for sale. The building, which now carries his name, is the hospital's outpatient services facility. Over the years, Biewend's generosity amounted to over $3 million. He was a major force in making Tufts Medical Center the center of excellence it is today.

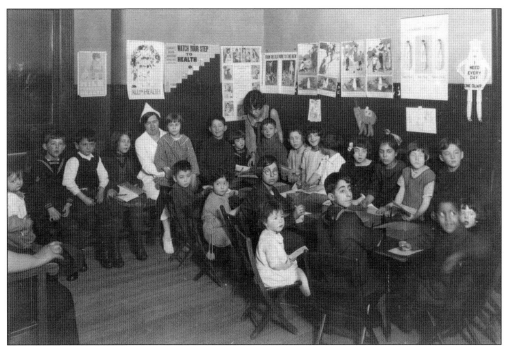

Frances Stern was a transformative figure in the Medical Center's history. She was one of the first to recognize the inadequacy of food distribution to the sick poor. Her efforts culminated in the establishment of the Frances Stern Food Clinic at the Dispensary. Among her innovations was the use of wax models of food, based on her belief that visual aids are a much more effective learning tool than words alone. In 1933, she initiated the first course for outpatient dieticians. She also understood the importance of diet in the treatment of childhood diabetes. Above is a nutrition education class for children around 1930. Below, patients await their weekly checkup at the Medical Center's diabetes clinic in 1935. A year before her death in 1947, Stern coauthored the book *Diabetic Care in Pictures*. She is quoted as saying, "The clinic is not just a room; rather it has been termed by the patient, 'a home.'"

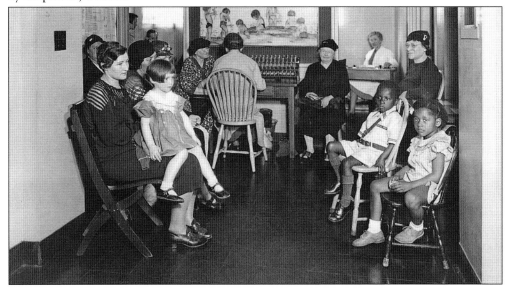

Frank Wing served as the first full-time director of the Dispensary from 1920 through 1950, the longest tenure in the institution's history. He was also director of the Floating Hospital from 1939 to 1951. Near the start of his tenure, the Dispensary was treating 30,000 patients a year, who made 150,000 visits. He was succeeded at the Dispensary by Abbie Dunks and at the Floating Hospital by Geneva Katz, a registered nurse.

Geneva Katz, RN, was named director of the Floating Hospital in 1951 and, through her leadership, brought the institution into the modern era of pediatric medicine. Because of her foresight, preparation, and restructuring of patient services, the hospital was ready to successfully serve the massive influx of pediatric polio patients that occurred in 1954. Katz's nurturing leadership helped foster an atmosphere of warmth and caring that led to the creation in 1963 of the nation's first Family Participation Unit, a small area where parents may remain overnight with their child.

Infrared light treatment, often called heat therapy, was one of several procedures used by the Physical Therapy Department in the late 1940s. Invisible, infrared energy reaches deep into soft tissues, muscles, joints, and bones. It increases blood circulation and can help relieve muscle stiffness and soreness. Today, infrared technology is used in a variety of other disciplines, including night vision, astronomy, and communications.

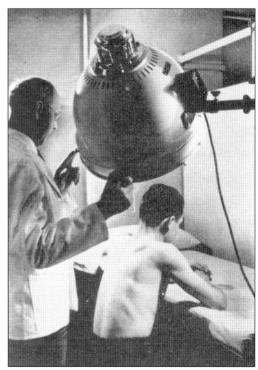

Medical education and training have been touchstones of the Tufts Medical Center mission since its inception. In the 1850s, the Dispensary played a clinical role in the training of Harvard Medical School students. Today's close affiliation with Tufts University School of Medicine began in the 1920s. In this 1955 photograph, the graduating class of laboratory technicians continues the legacy. Of the 35 graduates, 24 are shown here.

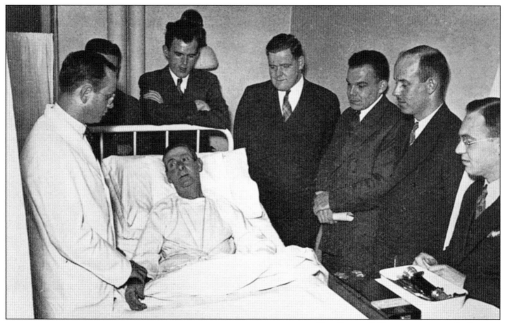

Dr. Samuel Proger, pictured above and at left, was a driving force behind the growth of the New England Medical Center as a unified entity. He started at the Dispensary as a resident working with Dr. Joseph Pratt in 1929. In 1946, Dr. Proger was elected president of the New England Center Hospital. Two years later, he became a full professor at Tufts University School of Medicine and physician in chief at the Medical Center. He remained in those positions until his retirement in 1971. In gratitude for Dr. Proger's care, Harry and Hannah Posner donated $1 million for a medical school dormitory and established an endowment for the hospital. In 1938, one of Dr. Proger's important and controversial initiatives was to place physicians on salary, a practice that continued until the late 1970s. He always insisted on providing the highest quality of patient care, saying, "To teach good medicine is to practice good medicine." Completed in 1973, the Proger Health Services Building is named in his honor.

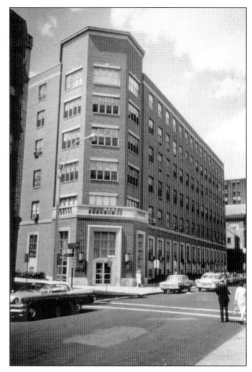

Dr. George Farnsworth was the medical and financial advisor to William Bingham II, a major benefactor of the Medical Center. Dr. Farnsworth was president of the Bingham Associates Fund, which was originally founded to advance rural medicine in Maine. Dr. Farnsworth was born in Boston and was a graduate of Harvard Medical School, Dr. Farnsworth interested Bingham in developing the Pratt Diagnostic Center and later expanding the Pratt to include surgical facilities. It soon became apparent that the Pratt Building did not have the space to satisfy the increasing demand for surgical services. In 1949, the Farnsworth Surgical Building, located at the corner of Harrison and Bennett Streets, was completed with Bingham's financial support. In the photograph below, taken the same year, a surgery is under way in one of the Farnsworth's operating rooms.

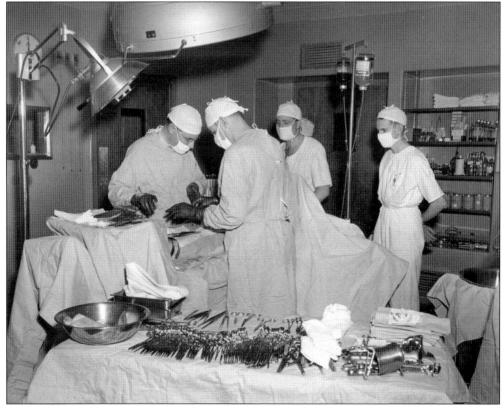

Experience had demonstrated that patients responded best when they were allowed to help themselves and one another under a nurse's supervision. Accordingly, the inpatient Rehabilitation Institute opened as a 10-bed pilot study in 1955. Through a combination of public and private funds, a five-story building, the first of its kind in New England exclusively devoted to rehabilitation, opened in 1958. In addition to vocational, occupational, speech, and hearing therapies, services included medical evaluation, social service, and psychological and vocational counseling. Most early patients of the institute suffered from industrial accidents. From these beginnings, the Division of Adult Physical Medicine and Rehabilitation has evolved. Today, physiatrists use alternatives to traditional, or open, surgery, reducing the potential risks and pain that can accompany surgical procedures. At left, a little girl receives therapy. Below, Joseph Parent, an amputee patient, tools leather in the occupational therapy department in 1955. Watching his progress are, from left to right, Joseph Ford, board member of the Dispensary; Edward Hannify, president of the Dispensary; Mary Herter and her husband, Massachusetts governor Christian Herter; and Arthur Rotch, vice president of the Dispensary.

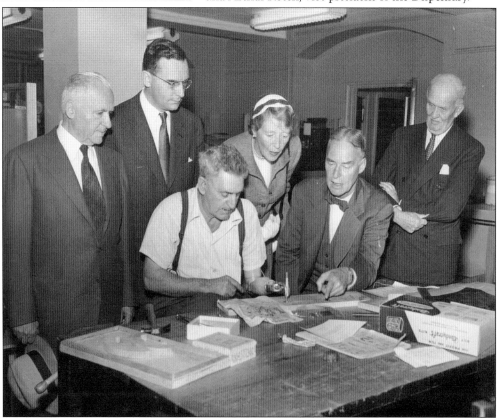

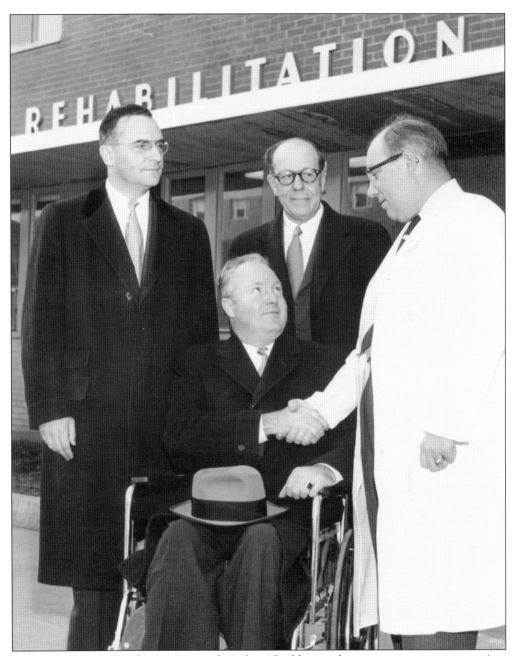

In the early 1950s, the Floating Hospital's Jackson Building underwent a major renovation. As a result, the hospital was prepared to handle the polio epidemic outbreaks in 1954 and 1955 that hit especially hard in the Greater Boston community. At the height of the epidemic, the Floating Hospital was the foremost polio treatment facility in Boston, caring for over 60 patients at a time. To make room for the polio patients, less seriously ill children were moved to adult wards at the New England Center Hospital. Seen here in a wheelchair, John Collins (later mayor of Boston) and his two children were among the hospital's patients. With the advent of a vaccine developed by Jonas Salk, the epidemic had passed by 1956, but the response of the Floating Hospital was one of its proudest moments.

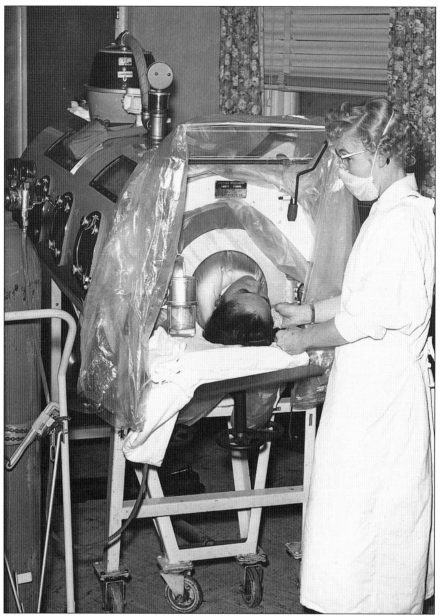

The negative pressure ventilator, or iron lung, was first used in 1929 to fight a polio epidemic. The first machine was constructed from two vacuum cleaners. It was also used to treat other diseases such as myasthenis gravis. Physicians who treated people in the acute, early stage of polio saw that many patients were unable to breathe when the virus paralyzed muscle groups in the chest. Inside the iron lung, the patient lay on a bed that could slide in and out of the cylinder as needed. The modern treatment method that has long since supplanted the iron lung involves positive pressure ventilation. Rather than placing the whole body in a low-pressure space to draw air into the lungs, a tube is placed in the airway to facilitate air intake with small amounts of positive pressure. Polio vaccination programs have virtually eradicated new cases of poliomyelitis in the United States. The iron lung has almost, but not quite, disappeared from modern medicine. In 2014, it was estimated that fewer than 10 people in the United States still live in an iron lung.

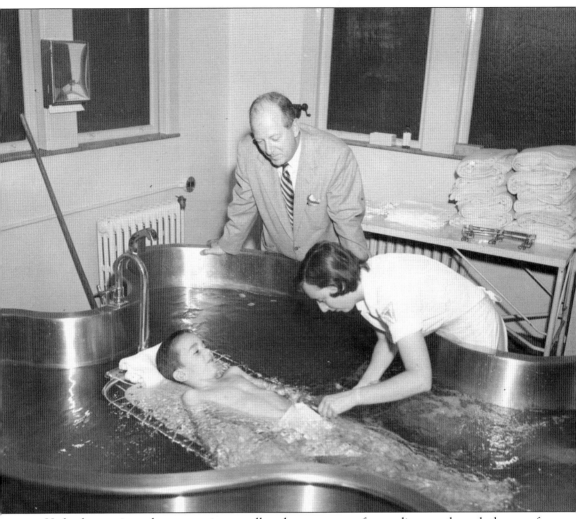

Hydrotherapy is used to treat pain, as well as the symptoms of some diseases, through the use of water. The Hubbard Tank, named for its inventor, engineer Carl Hubbard, is used when a patient requires full-body immersion. Its figure eight shape allows a therapist to reach the patient without getting wet. The tank has an aerator to provide gentle massage with buoyancy and heat to assist painful or weakened muscles that have a limited range of motion. It is designed to allow the patient to exercise underwater while lying on a stretcher, as this c. 1957 photograph of a young polio patient shows. Hydrotherapy is also especially useful in the treatment of patients with extensive burns. This $5,000 tank was purchased for the Physical Therapy Department through donations raised by the Junior League of Massachusetts.

The Floating Hospital's medical care extended beyond children's physical ailments to treat their psychological illnesses as well. Dr. Robert Geiser is pictured with Dr. Lieselotte Suskind, shown here holding a child in 1964. Dr. Geiser's influential book *Hidden Victims*, published in 1979, advanced the notion that children were being victimized through sexual abuse and exploitation in vast numbers and that no one was paying any attention to the problem.

Emmett Kelly's "Weary Willie" creation was a tragic figure. His trademark routine was as a clown dressed as a tramp who would be seen sweeping up the spotlight rings after the other performers. He was a master of pantomime who never spoke a word but whose simplicity and honesty brought joy to countless children. He spent much of his free time visiting children's hospitals, where he brightened the day with a touch of tenderness.

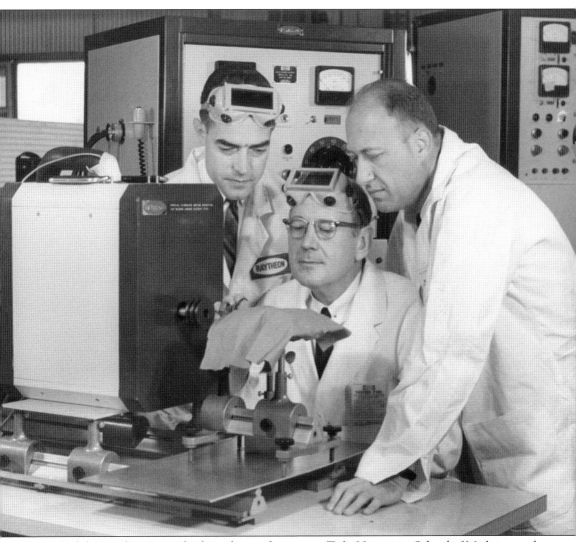

Dr. Ralph Deterling Jr. was both professor of surgery at Tufts University School of Medicine and surgeon in chief at New England Medical Center from 1959 to 1975. In addition to his positions at the school and Medical Center, he was also affiliated with several other medical institutions around Boston, including Boston City Hospital. He played a vital role in establishing the New England Medical Center as the primary teaching hospital for Tufts University School of Medicine. In this photograph, Dr. Deterling (right) is working with a biophysicist from the Raytheon Company (far left) and a surgery research fellow at the hospital. Although Dr. Deterling's research primarily focused on cardiac surgery, he is pictured here in a laboratory where laser light was used to treat cancers that had been transplanted into animals. Today, lasers are routinely used in surgery and skin treatments, but when first invented in 1960, they were, as Charles H. Townes put it, "a solution looking for a problem."

The Saltonstalls have been a prominent Massachusetts family since Puritan times. They have also been generous supporters of Tufts Medical Center for decades. Bill "Salty" Saltonstall was chairman of the board of governors. He founded the William L. Saltonstall Society, which celebrates the generosity of spirit of benefactors who have included Tufts Medical Center in their estate plans. Leverett Saltonstall, William's cousin, seen second from right at a Medical Center event around 1955, was Massachusetts governor and US senator.

Tufts Medical Center and the Floating Hospital for Children are nationally recognized for the quality of their care and dedication to the health needs of all without regard to the patient's financial status. Many celebrities and political officials have stopped by the hospital to recognize and celebrate its contributions to health care and to bring a bit of cheer to patients young and old. Here, Vice Pres. Walter Mondale (right) and Sen. Edward Kennedy (left) accompany hospital president Jerome Grossman (center) on a visit to a children's ward.

The first Neonatal Intensive Care Unit (NICU) at the Floating Hospital was established in 1963. Its team delivers intensive medical, surgical, and nursing care for premature and critically ill newborns in a state-of-the-art 42-bed facility. As a designated tertiary care unit, it is fully equipped with electronic monitoring, life-support systems, and diagnostic and therapeutic services. A specially trained transport team is ready around the clock for ambulance or helicopter transport of infants from across the New England region who need intensive emergency care. The NICU, along with the hospital's labor and delivery and maternity units, provide seamless medical support for at-risk newborns. The Floating Hospital was the first medical center in Massachusetts to be selected by the March of Dimes for its NICU Family Support program, a key collaboration that benefits both patients and parents. Pictured at right is Dr. Ivan Franz, former president of the Floating Hospital. Below, in a 2002 photograph, Dr. John Fiascone, then medical director of the NICU, and neonatologist Dr. Barbra Shephard care for triplets in the NICU.

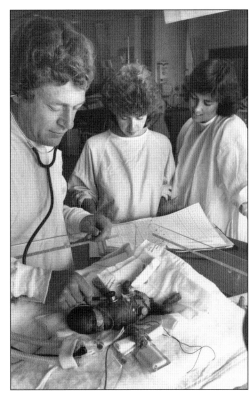

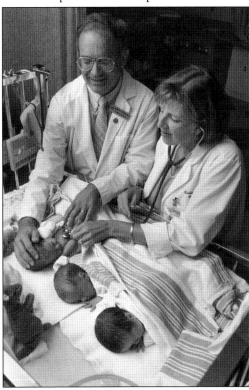

Once known as the Main Line El, the MBTA's Orange Line originally consisted of an elevated line and subway that ran from Everett to Forest Hills in Boston. The current name, assigned in 1965, is derived from Orange Street, an old name for the section of Washington Street immediately south of downtown. The Washington Street tunnel, which runs beneath the hospital, is still in use. In 1987, the Washington Street El south of the Chinatown station was closed to allow the Orange Line to be redirected and tied into the new Southwest Corridor. A new subway stop—originally named New England Medical Center, now Tufts Medical Center—was constructed to serve the hospital. The structures in this 1965 photograph are, from far left to right, the Tupper Building, the later location of the Sackler Building, the Ziskind Building, the Pratt Diagnostic Clinic, the Boston Dispensary, and the Jackson Building. At the bottom left where the excavation starts would be the site of the Tufts Dental School building, and on the right, where the road bends, would be the site of the current Floating Hospital.

Dr. Sheldon Wolff earned a stellar international reputation at the National Institute for Allergy and Infectious Diseases. He came to Tufts Medical Center in 1977 to become physician in chief. Following his special field of interest, Dr. Wolff made important contributions to the broad study of inflammation and infection, fevers of unknown origins, and specifically to diseases such as AIDS and toxic shock syndrome. At the Medical Center, he launched several new divisions, revamped the intensive care units, doubled the inpatient census, enhanced the teaching programs for medical students, and built a world-class research program. A natural leader, Dr. Wolff excelled equally at patient care, research, and teaching. His impact on the advancement of the hospital cannot be overstated.

Earl S. Tupper, business leader, philanthropist, and inventor (with Tupperware being his most famous invention), was a lifelong friend and patient of Drs. Samuel Proger and Joseph Pratt. In appreciation of the extraordinary relationship he had with the hospital, Tupper bequeathed funds upon his death that created the Tupper Research Institute and made possible the purchase of the building at 15 Kneeland Street in Boston that bears his name.

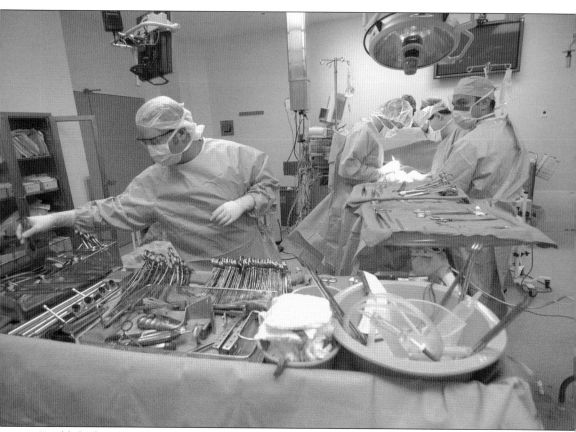

Established in 1982, the hospital's Heart Failure and Cardiac Transplantation Center performed its first heart transplant in 1985. Since then, over 320 transplants have taken place at Tufts Medical Center. The center has become internationally renowned for developing state-of-the-art therapies and for providing high-quality personalized care. From 2007 to 2012, Tufts Medical Center performed more heart transplants than any other hospital in New England. In the 15 months beginning with January 2014, thirty-five heart transplants were performed. Heart failure patients are placed on the transplant list if they are in end-stage heart disease, with a life expectancy of two years or less. Donor hearts are allocated based on the severity of the patient's disease, blood type compatibility, and body weight. Currently, there are about 80 Medical Center patients on the transplant list. The program became one of approximately 25 centers nationwide to be accredited as a training program in this highly specialized field.

Dr. Jane Schaller (left, shown with a medical student), an internationally known specialist in rheumatology and child's rights advocate, was pediatrician in chief at the Floating Hospital and professor and chairman of the Pediatrics Department at Tufts School of Medicine during the 1980s. She tripled the physician staff and led the accreditation of the nephrology and rheumatology divisions. Dr. Schaller often said that, of all her accomplishments, her greatest source of pride was being part of the Floating Hospital's mission of attending to the needs of the whole child.

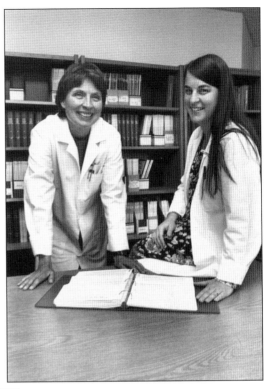

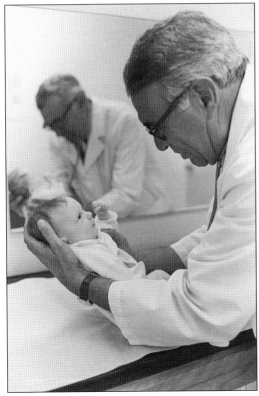

Dr. Sydney Gellis was the Floating Hospital's pediatrician in chief from 1965 to 1980. He was the driving force in expanding the hospital's range of medical services, as well as overseeing the building of the new Floating Hospital. During his time at the Floating Hospital, Dr. Gellis published a weekly *Pediatric Notes* newsletter, which had a wide distribution to pediatricians all across the United States. In 1993, he was the recipient of the Lifetime Achievement Award in Pediatric Medicine Education, given by the American Academy of Pediatrics.

115

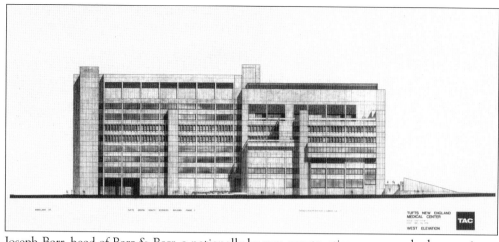

Joseph Barr, head of Barr & Barr, a nationally known construction company, had a prominent role in the expansion of the Medical Center. He initially served as an advisor on the Pratt Building construction project. Later, he became a director of the New England Medical Center and served on the hospital's board of governors. Barr and his company were selected to build Tufts Medical School's Posner Hall dormitory on Harrison Avenue in 1951 and the combined Tufts Dental Health Sciences Building and New England Medical Center's Proger Building in 1973. When funding was finally available, he was chosen to build the new Floating Hospital for Children, which was completed in 1983. Pictured above is the architect's drawing for the combined dental and health sciences (Proger) building. The image below shows, from left to right, the Dental School, Proger Building, Floating Hospital, and the Jean Mayer USDA Human Nutrition Research Center on Aging.

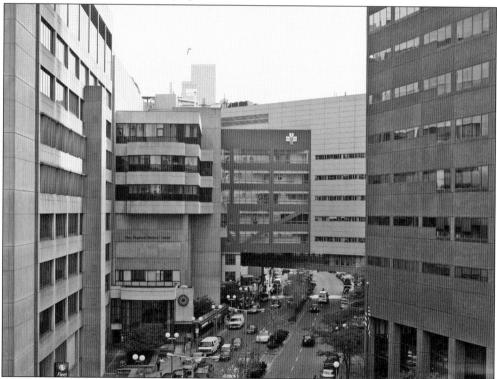

As Tufts Medical Center's president and chief executive officer during the 1980s, Dr. Jerome Grossman is best known for bringing the institution successfully into the competitive world of HMOs. Dr. Grossman saw that the hospital, to remain in the forefront of the rapidly changing health care market, needed a new operating structure and additional modern facilities. During his tenure, the new Floating Hospital was built, as well as the Proger, North, and South Buildings. Through his leadership, the Medical Center grew to be the sixth-largest hospital in the state and one of the most respected academic medical centers in the country.

In 1943, Dr. Samuel Proger treated Jacob Ziskind (left) for an illness and charged him the standard $25 diagnostic fee. A successful and wealthy businessman, Ziskind was surprised and impressed that his wealth was not being taken advantage of, and thus responded with an offer to make a voluntary contribution to the hospital. Dr. Proger explained that the hospital was in need of additional funding for its pioneering medical research work, and as a result, Ziskind generously donated $5,000 to assist with the Medical Center's research efforts. This marked the beginning of a long and beneficial relationship between Ziskind and the Medical Center. Over the ensuing years, Ziskind and the trust he and his wife had established contributed over $2 million to the Medical Center. A large portion of this money went to buy the medical research building later named for him.

The Kiwanis Pediatric Trauma Institute (KPTI) is the world's first trauma recovery unit established exclusively for injured children. The special unit was developed as a partnership between the New England District of Kiwanis and the Floating Hospital for Children. Since 1981, it has provided the highest level of expertise available to treat the most seriously injured children. The institute is the prime financial supporter of the hospital's Pedi Trauma Emergency Care Unit and the Boston MedFlight trauma program. KPTI's Community Safety Programs reach more than 33,000 children and their families throughout New England each year. Dr. Carl-Christian Jackson, the hospital's leading pediatric trauma surgeon, is pictured above with a patient. A MedFlight helicopter is seen below on the hospital's KPTI-sponsored helipad. Its pioneering trauma and injury prevention programs set high standards for this field of medical care.

The Cam Neely Foundation for Cancer Care was launched in 1995. Created to help cancer patients and their families during treatments, to date it has raised over $28 million for Tufts Medical Center. The essence of the foundation and its mission is to provide comfort, support, and hope to cancer patients and their families. The foundation supports many cancer-related programs at the Medical Center. The Neely Center for Clinical Cancer Research (NCCCR) is the core facility, dedicated to coordinating all aspects of adult and pediatric oncology and hematology clinical research. The Neely House has provided over 6,000 families with a convenient, comfortable place to live and remain close to their family member in the most trying of times. The Neely Cell Therapy and Collection Center provides stem cell collection services to outpatients. The Pediatric Hematology/Oncology Outpatient Clinic (PH/OOC) and the Neely Pediatric Bone Marrow Transplant Unit are also integral parts of the center. Shown above is the vibrant, colorful playroom in the PH/OOC, which is sponsored by the Neely family. Seen below at the dedication of the PH/OOC are, from left to right, Ellen Zane (then chief executive officer of Tufts Medical Center), Scott Neely, Jack Neely, Dr. John Shreiber (then chief administrative officer of the Floating Hospital), Ava Neely, Paulina Neely, and Cam Neely.

In 1999, Tufts Medical Center became the first hospital in New England to pioneer the Gamma Knife and operates one of only three Gamma Knife centers in New England. Tufts Medical Center has performed over 2,300 procedures to date. The name is misleading—there are no knives. Instead, the technology focuses beams of gamma radiation on brain tumors or other abnormalities. Because there are no incisions, Gamma Knife treatments are safer than traditional brain surgery. The treatment location receives an effective dose of radiation, but the beams pass harmlessly through nearby healthy tissue. Gamma Knife surgery can be a safe and painless option for patients who are too frail for traditional surgery, and it is extremely effective for treating very small tumors or those in hard-to-reach places.

In 1997, Dr. Jane Schaller, chairman of pediatrics, was approached by a referring pediatrician to provide medical care to children from Klintsy, Russia, and Gomel, Belarus, who suffered from the aftereffects of the Chernobyl nuclear disaster of 1986. She agreed to have the Floating Hospital function as the principal acute care medical institution for the Chernobyl Children's Project, USA, and appointed Dr. John Kulig as its medical director. Over 15 years, the project brought approximately 1,500 children to live with families in Boston suburbs for one summer month. During their stay, they received medical care at community hospitals and dental care from local volunteer dentists. The Floating Hospital treated approximately 500 children with various forms of cancer, heart disease, kidney disease, cataracts, severe dental and gum problems, bone diseases, and scoliosis.

Boston sports teams are longtime supporters of the Medical Center. Their generous donations of funding have contributed to the growth and success of several major initiatives. In addition to team support, many individual players have worked with the hospital on its fundraising campaigns. Paul Pierce, former star basketball player and captain of the Celtics, served on the hospital's board of governors. The Paul Pierce Center for Minimally Invasive Surgery was named in his honor in 2007. Equally important over the years has been the time the athletes have spent with patients, giving them comfort and support, especially the children. As far back as the 1950s, Tom Brewer and Don Gile of the Red Sox visited the children at the Floating Hospital. Recently, Zdeno Chara of the Boston Bruins cheered up the children by signing autographs. Cam Neely, president of the Boston Bruins and Hockey Hall of Famer, has been a major contributor to the success of the hospital for many years. Pictured here is Kevin McHale, Celtics Hall of Famer.

Tufts Medical Center is located in the heart of Boston's Chinatown, the center of Asian American life in New England. The Medical Center has enjoyed long-standing outreach partnerships with a wide variety of community-based organizations and has created programs dedicated to meeting the health care needs of its neighbors in the Asian community. Some of the programs include the Asian Health Initiative, the Asian Pediatric and Adolescent Clinical Services, and the Asian Access Program, which also helps with many of their social service needs. Newer programs include the Asthma Prevention and Management Initiative and See, Test & Treat, an annual women's health screening. Above, hospital volunteer Tin Choi interprets for patient Chu Ha, and below, May Wu (center) of the Assian Access Program is presented with gifts from the community.

Tufts Medical Center continues to evolve to meet the ever-changing advances in health care. A prime example of how the hospital leveraged and maximized these advances has taken place in the way the hospital approaches cardiovascular medicine. The Medical Center had developed a full array of cutting-edge cardiac diagnostic and treatment programs, but they were not being fully coordinated and utilized to maximize their effectiveness. The solution was to create the Cardiovascular Center (CVC). Today, all the hospital's cardiac resources reside under a single organizational umbrella. For physicians and their patients, it means a streamlined and collaborative approach to patient care and easy access to the hospital's multidisciplinary team of cardiovascular specialists and broad range of vascular resources.

Shown here is the da Vinci Surgical System, a sophisticated robotic platform designed to expand the surgeon's capabilities and offer a minimally invasive, state-of-the-art option. With da Vinci, small incisions are used to insert miniaturized instruments and a high-definition 3-D camera. The da Vinci senses the surgeon's hand movements. At the same time, the latest robotic and computer technologies seamlessly scale, filter, and translate those hand movements electronically into scaled-down micromovements to manipulate the tiny proprietary instruments. It also detects and filters out any tremors in the surgeon's hand movements so that they are not duplicated robotically. Seated at the da Vinci console, a surgeon views a magnified, high-resolution 3-D image of the surgical site inside the body. Although it is often called a robot, the da Vinci Surgical System cannot move or operate on its own; the surgeon is in complete control. More than 1.5 million da Vinci procedures have been performed worldwide since 2000.

Ellen Zane was president and chief executive officer of Tufts Medical Center and the Floating Hospital for Children from 2004 to 2011 and was the institution's first female chief executive. A charismatic visionary and an effective leader, Zane was uniquely qualified and successful at leading the institution forward as it emerged from its relationship with the Lifespan Group. She restored Tufts Medical Center's pioneering spirit, financial independence, and unique role in the rapidly changing world of health care.

Dr. Michael Wagner is the current president and chief executive officer of Tufts Medical Center and the Floating Hospital for Children, as well as an associate professor at Tufts University School of Medicine. Under Dr. Wagner's collaborative leadership style, Tufts Medical Center has made significant, wide-ranging strides in creating, organizing, and enacting a variety of quality, safety, and patient engagement initiatives designed to ensure that patients receive the highest-quality care.

At a hospital, a patient's, especially a child's, reaction to a procedure can never be predicted, no matter how simple it may be. With a little girl as young as the one at right, even getting weighed can seem scary. On the other hand, the baby below seems quite happy and healthy. With this in mind, the hospital has always kept the emotional well-being of its patients and their families at the forefront of its treatment programs. The Dispensary and the Floating Hospital pioneered a family-centered philosophy. Tufts Medical Center is dedicated to offering the highest level of care and family support while remaining committed to making new research advances and training the next generation of leaders in medicine.

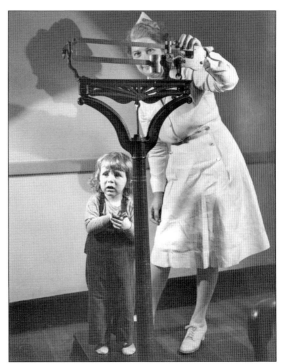

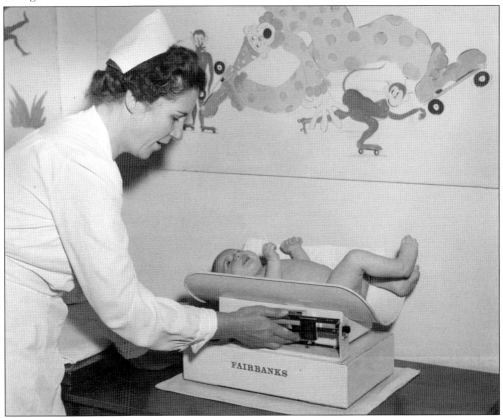